IMAGES
of America

OHIO'S
BUCKEYE TRAIL

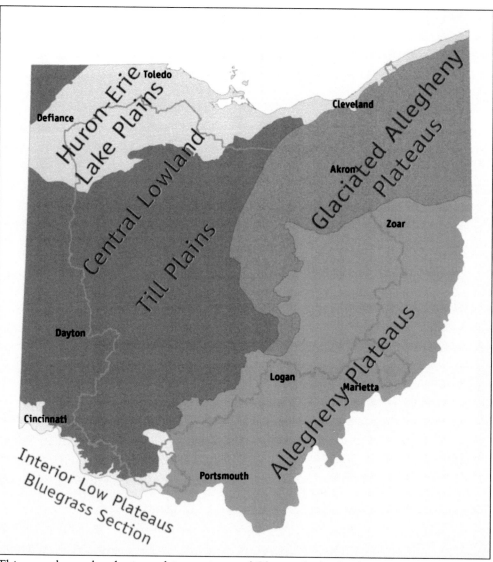

This map shows the physiographic provinces of Ohio with the Buckeye Trail superimposed. Included are the province names and significant communities near the trail. Physiography is the branch of geography that is the descriptive study of the earth's surface. Each physiographic province has physical features that show a common geomorphic history. (Courtesy of Richard Lutz, Buckeye Trail Association.)

ON THE COVER: These well-dressed men are sitting above a covered bridge crossing the Great Miami River in the 1880s. The city of Piqua is in the background. Piqua was settled in 1780 near the site of the Battle of Pickawillany, where British forces were attacked by Ottawa and Ojibwe warriors. Incorporated in 1807, Piqua developed along with the Miami & Erie Canal. Piqua is also the name of one of the five divisions of the Shawnee people. (Courtesy of the Ohio History Connection.)

IMAGES
of America

OHIO'S
BUCKEYE TRAIL

Norman Fox

ARCADIA
PUBLISHING

Published by Arcadia Publishing
Charleston, South Carolina

Printed in the United States of America

Library of Congress Control Number: 2016959100

For all general information, please contact Arcadia Publishing:
Telephone 843-853-2070
Fax 843-853-0044
E-mail sales@arcadiapublishing.com
For customer service and orders:
Toll-Free 1-888-313-2665

Visit us on the Internet at www.arcadiapublishing.com

This book is dedicated to the staff and members of the Buckeye Trail Association and to all the volunteers who build, maintain, protect, and promote the trail and foster the reality of a hiking trail connecting the four corners of Ohio.

CONTENTS

ACKNOWLEDGMENTS

Writing a book of this scope required the help of many people from all over the state of Ohio. I would like to especially thank Lily Birkhimer of the Ohio History Connection for her help with the Ohiomemory.org archive. Unless otherwise noted, images in this volume came from that archive. This project could not have been completed without the consistent help of Andrew Bashaw, director of the Buckeye Trail Association, and his staff in Shawnee: Sally Sugar, Richard Lutz, and Barry Unger. I would like to thank Liz Gurley of Arcadia Publishing for her encouragement and prodding at times.

Other images in this book were provided courtesy of: Lori Jo Folger, David Everett of Hiram College, Barb Bennett of the Muskingum Watershed Conservancy District, Jeff Wunderly of Little Cities of Black Diamonds Council, Jessica Cyders of the Southeast Ohio History Center, Ann Cramer of Wayne National Forest, Scott Saunders of Antiochiana at Antioch College, and Neal Brady of the Miami & Erie Canal Corridor Association.

Several others provided permission to include images in this book: Teresa Bradstock of the Delphos Canal Commission, Susan Lang of the Pemberville Library, Michelle Epple of the Defiance Public Library, and Marnie Pratt of the Wood County Public Library.

Several books have been written about Ohio's Buckeye Trail and about regions that the Buckeye Trail passes through. The following works give a historical perspective and were especially helpful:

Bashaw, Andrew, Sandra Landis, Dana White, and John Winnenberg. *At the Glacier's Edge.* Sunday Creek Associates, Little Cities of Black Diamonds Council, 2007.
Chiddister, Diane, et al. *Two Hundred Years of Yellow Springs.* Yellow Springs, OH: The Yellow Springs News Inc., 2005.
Dischinger, Hilda. *The Zoar Story.* Strasburg, OH: Gordon Printing Inc., 1999.
Hall, John F. *The Geology of Hocking State Park.* Information Circular No. 8. Columbus, OH: State of Ohio Division of Geological Survey, Division of Parks, 1953.
Pond, Robert J. *Follow the Blue Blazes.* Athens, OH: Ohio University Press, 2003.
Schneider, Norris F. *The Muskingum River, A History and Guide.* Columbus, OH: The Ohio Historical Society, 1968.

INTRODUCTION

Ohio's Buckeye Trail (BT) is a revelation of Ohio's important stories. Each year since 1959, along our 1,400-plus-mile state trail, the Buckeye Trail Association (BTA) and its partners develop a little more of this sinuous path around the Buckeye State. The BT connects many of Ohio's most fascinating points of natural wonder and shared cultural heritage into a vision of one continuous and circular journey. Walking or hiking the BT is an exploration of Ohio's collection of important stories and their relevance to our lives today.

Who are we, why are we here, and where are we going? The answers to these timeless questions can be explored through the history of the places that the BT guides us through. Often these stories are hidden in plain view during a peaceful hike through a county metropark, a backpack trip through Ohio's only national forest, or a stroll down a historic village main street, all beneath those two-by-six-inch painted blue blazes guiding us along the BT. This book, like the brush stroke of a BTA volunteer painting one of those blazes, is just a taste of the whole story on or near the BT. There is much more to reveal in both the depth and scope of the stories touched on here.

The most recent story on the BT is the BTA itself. This latest chapter began in 1958 with a small group who shared one big idea to, at first, create a long-distance hiking trail from the shore of Lake Erie to the bluffs overlooking the Ohio River "to provide such an environment where those who choose may aspire to a high goal and more useful life . . . and have lots of fun while they are at it." The BT "should be as endless and as boundless as the energy and the imagination of those who would use it," according to Merrill Gillfillan's 1958 *Columbus Dispatch* article introducing the idea of the BT to the general public.

That small group and its vision persisted and grew. Today, the BTA is a membership-based, volunteer-driven organization connecting many of Ohio's greatest places together into one boundless experience. How do we share this far reaching story—all of these countless stories—in some coherent manner? Some stories are memorialized at points along the trail. Many more stories and their context stretch out on the landscape the BT passes through beyond the trail corridor and across regions. All of these stories find their roots in the land. People have populated, been impacted by, and written their stories into the landscape in continuous waves because of the resources the land offered them in the first place. For this reason, the chapters of this book are divided by Ohio's general physiographic provinces. Also, the observant Buckeye Trail hiker will realize that several of the places highlighted here are not directly on the route of the BT but are included to add further context to the story the BT tells as it passes through the landscape as one thin line.

Imagine that Ohio's Buckeye Trail has been in development, not since 1959, but since the formation of the land itself. What would the BT be without the glaciers rounding off our northern foothills, depositing lobes of moraines across western Ohio, and gouging gorges out of bare rock? Imagine a BT without Old Man's Cave, Cedar Falls, or Ash Cave at Hocking Hills State Park. What would the BT be without the earliest Americans laboring to create monuments such as

Fort Ancient, Fort Hill, and Serpent Mound? Imagine the only thing these early engineers and astronomers forgot to do was paint those blue blazes to guide them in southwest Ohio. What would the BT experience be today without the struggle between the expansion of settlement from a young American nation and the Ohio country's heroic native-born leaders like Cornstalk, Tecumseh, and Chief Logan defending their homeland? These stories are memorialized at Fort Laurens, Marietta, the Big Bottom Massacre site, and Fort Defiance, among others. What would the BT experience be without the laborers who dug and built the Miami & Erie Canal through places like the Johnston Farm and Indian Agency and the battleground of Pickawillany? What would the BT experience be without the stories still passed down of our ancestors losing their horses and freshly baked pies to Morgan's Raiders near the village of Shawnee? What would the BT be without the development of our railways to access the Hocking Valley coalfields or connect and create towns across Ohio's northern tier? What would the BT be without the conservation movement that resulted in the creation of Wayne National Forest, Cuyahoga Valley National Park, and our state lands, creating places for us all to steward and enjoy? And what would the BT be without that small group of people with a bold idea to tie it all together into one great story? Exploring the BT in person is an experience in time travel for your imagination.

Consider taking the next step in your journey. Get yourself a hiking map from the BTA and follow the blue blazes to put your boots in that place. Imagine the meltwater gushing from receding glaciers carving gorges out of the rock that your hand is resting on. Imagine a long day of hauling baskets of freshly dug dirt uphill to create the world's largest effigy of a snake as you take in the view over the edge of an ancient meteorite impact crater at Serpent Mound. Imagine canal boats filled with the remnants of the Wyandot Nation passing slowly before you standing on the Miami & Erie Canal Towpath. Imagine helping families of escaped slaves pick their way in fear through Appalachian Ohio along the Underground Railroad, making their way to places like the Fairport Harbor Lighthouse on their journey to freedom as you take in the beach view at the BT's northern terminus. Imagine the buzz in camp during the Civil War as you sit on the bench at Camp Dennison awaiting orders to defend Cincinnati from a probable attack from Gen. John Hunt Morgan's men on their raid through the north. Imagine watching Orville and Wilbur Wright's trial run of the latest Wright Flyer across the Huffman Prairie Flying Field as the wind whips through your hair. Remember your grandfather's stories of his Civilian Conservation Corps days as you stop to gaze at the blue blazes lined up on the pine trees he may have planted on a once-barren landscape.

Imagine, enjoy, and share your experience with others as the Buckeye Trail shared with you.

One

FAIRPORT HARBOR TO AKRON AND PAINESVILLE TO ZOAR

The Buckeye Trail starts in northern Ohio at Headlands Beach State Park near Fairport Harbor on Lake Erie and ends at the Ohio River at Cincinnati. After several years of expansion, the trail now heads south in two directions, forming two sides of the Little Loop of the Buckeye Trail. The western side passes through southeast Cleveland and Cuyahoga Valley National Park to Akron following the Ohio & Erie Canal corridor, while the eastern side travels through the more rural landscapes east of the Cleveland area. The two sides of the loop join at the town of Crystal Springs north of Massillon. From there, the Buckeye Trail follows the Ohio & Erie Canal Towpath Trail through Bolivar and on to Zoar.

The area that extends from Lake Erie south to Zoar is part of the Glaciated Allegheny Plateau physiographic province of Ohio except for a sliver of land next to Lake Erie. Limestones and sandstones of the middle Paleozoic (350–190 million years ago) are overlain by relatively young glacial deposits consisting of till (sand and gravel) deposited by glacial ice and several landforms deposited by running water during the Pleistocene epoch, which ended about 10,000 years ago.

The Little Loop in the northern part of the area follows the Cuyahoga River as it flows south from its headwaters east of Cleveland near Middlefield to Akron, where it encounters the drainage divide separating the Lake Erie watershed from the Ohio River watershed. From Akron, the river turns north, flowing through the Cuyahoga Valley and on to Cleveland, where it flows into Lake Erie. The path of the river and the landscape, as we see them today, are the result of the continental glaciation mentioned above.

Most of the Cuyahoga River watershed is part of the Connecticut Western Reserve, established by charter from King Charles II of England in the 1600s. Native Americans had used the valleys of the Cuyahoga, Tuscarawas, and Muskingum Rivers to travel between Lake Erie and the Ohio River. Later, in the 19th century, escaped African American slaves used the same route, along with many others in Ohio, to travel north to Lake Erie and freedom.

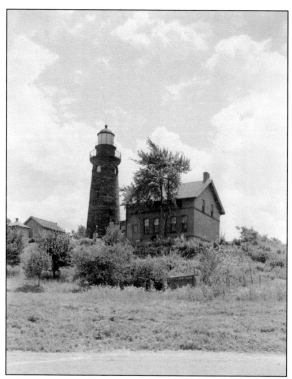

The northern terminus of the Buckeye Trail is near Fairport Harbor, about 20 miles northeast of Cleveland. The area around the harbor is home to the largest natural sand beach in Ohio and, due to the stormy nature of Lake Erie, is the site of the Fairport Harbor Lighthouse. The original lighthouse was built in 1825 and was an important stop on the Underground Railroad before the Civil War. It now serves as the Fairport Harbor Marine Museum.

The current lighthouse is known as the West Breakwater Lighthouse and is located at the mouth of the Grand River. It was built to replace the old lighthouse, which was falling into disrepair. In 1917, Congress allowed construction of a new lighthouse, but plans were delayed by the First World War. The lighthouse became operational in 1925 and is a critical navigation aid for Lake Erie.

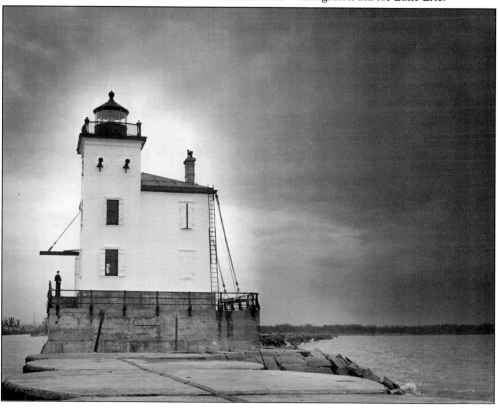

The photograph at right gives a view of the Fairport Harbor skyline. In the background is the old lighthouse, while piles of salt belonging to the Morton Salt Company occupy the middle ground. Salt is extracted from mines under Lake Erie and brought to the surface in Fairport for processing. These mines mainly provide road salt needed by many communities during the winter months. Part of the Morton Salt Company processing facility is shown below.

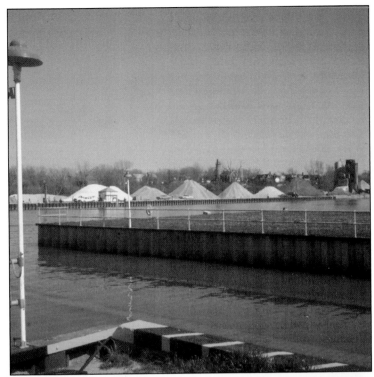

This group of hikers is relaxing at the North Chagrin Trailside Museum. Part of Cleveland Metro Parks since the 1920s, the North Chagrin Reservation is composed of wildlife sanctuaries and recreational areas. Approximately 1,700 acres in size, it is the northernmost unit in the Cleveland Metro Parks system.

Approximately six miles south of the North Chagrin Reservation is the village of Chagrin Falls. Incorporated in 1844, the village is well known for a natural waterfall on the Chagrin River, which flows just to the west of the village. Settlers from New England were attracted to the falls in 1833 while looking for a site with water power. By the mid-19th century, several factories and a gristmill were established along the banks of the river.

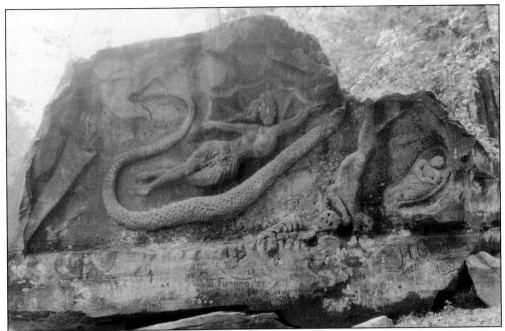

Squaw Rock is an outdoor sculpture on the South Chagrin Reservation near the Chagrin River. The carving was created in 1885 by Henry Church Jr., an avant-garde artist, on a large piece of Barea sandstone. Depicted on the rock are a native American woman, a serpent, a panther, a quiver of arrows, a skeleton, an eagle, and a papoose.

James Garfield was born in 1831 and spent his childhood in this house. In 1876, he acquired a larger home in Mentor known as Lawnfield. By then, he was representing the 19th Congressional District and wanted a permanent residence where he could spend the summers when Congress was in recess. Garfield was president of the United States from March 4, 1881, until he was assassinated on September 19, 1881.

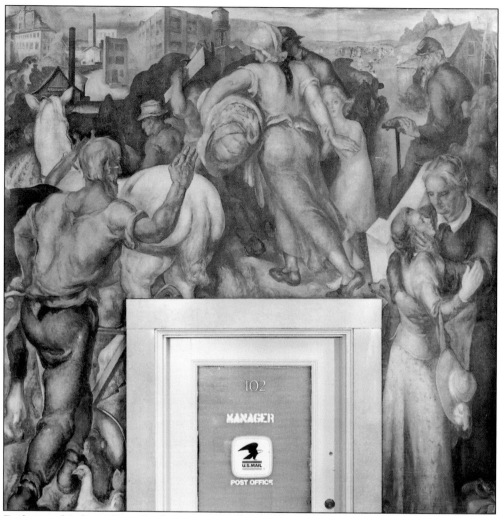

Drift toward Industrialism, also known as *Exodus to the Cities,* was painted by Karl Anderson in 1937 as a color mural in the post office building in Bedford. The mural was funded by the US Department of the Treasury Section of Painting and Sculpture during the Great Depression. The mural portrays the migration of people from rural areas to industrial cities. In 1988, Connie Girard photographed it for *Timeline* magazine.

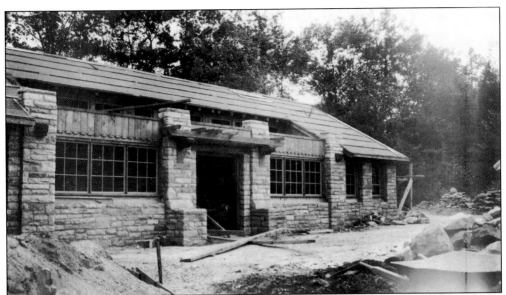

The Brecksville Nature Center (shown under construction) was built in 1939 by the Civilian Conservation Corps, part of the Works Progress Administration under Pres. Franklin D. Roosevelt. The nature center is near the north end of the Brecksville Reservation, a landscape carved by the last continental glacier in Ohio. At right is a hiking trail within the reservation.

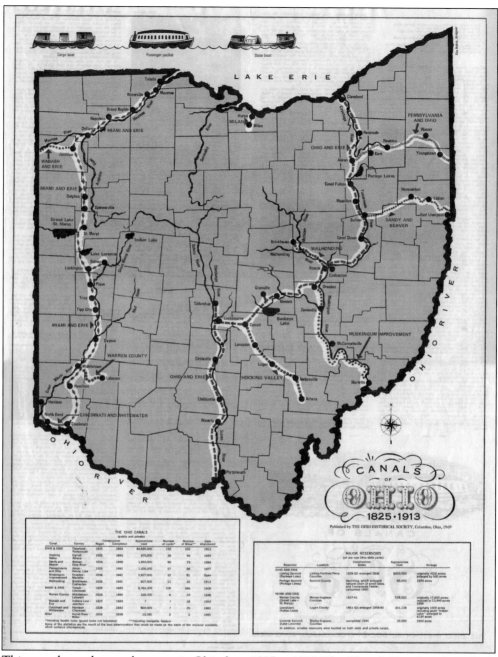

This map shows the canal systems in Ohio from 1825 to 1913. The Ohio & Erie Canal was built first, followed by the Miami & Erie Canal in 1827. Other main canals, feeders, and side cuts came later. By 1855, the canal system served 44 of the 88 counties in Ohio and extended almost 1,000 miles. After 1855, the railroads increased competition with the canals, and by the turn of the century, canals were in decline.

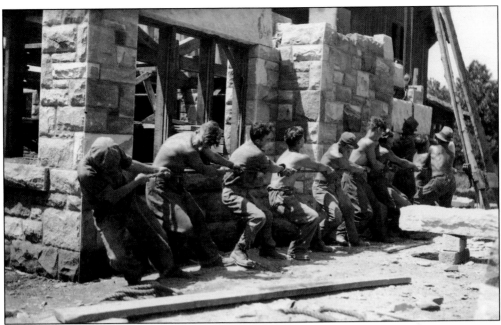

This worthy crew is building a combination shelter house and caretaker home at Virginia Kendall Park north of Akron. The park was originally part of the Akron Metropolitan Park District and is now part of Cuyahoga Valley National Park. The crew is part of the Civilian Conservation Corps, tasked with developing and preserving America's natural resources. In the 1930s, there were 110 Civilian Conservation Corps camps in Ohio. Below is the completed shelter house and home.

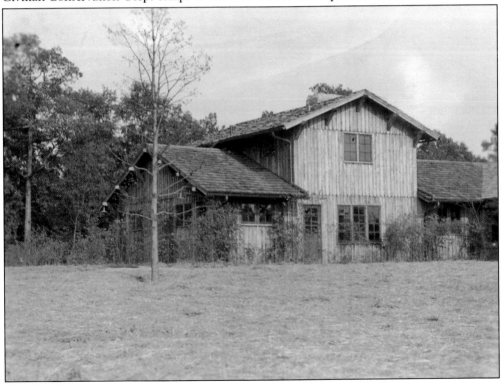

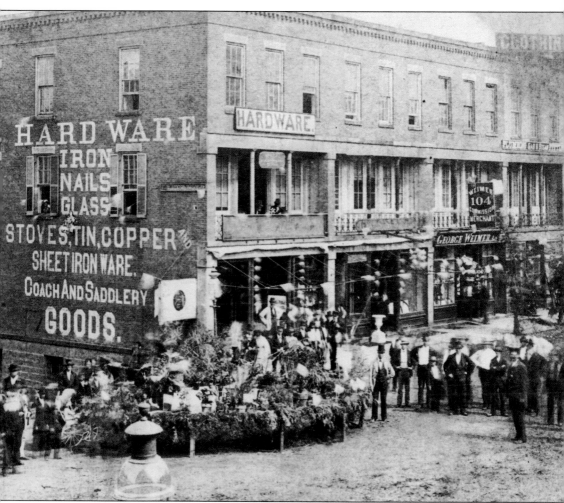

This hardware store was on the corner of Howard and Market Streets in downtown Akron in 1937. Akron was founded in 1825 at the summit (or drainage divide) of the Ohio & Erie Canal. The name *Akron* is derived from a Greek word meaning "high point." The town was settled by many Irish laborers employed to build the canal. In 1841, Akron became the seat of Summit County.

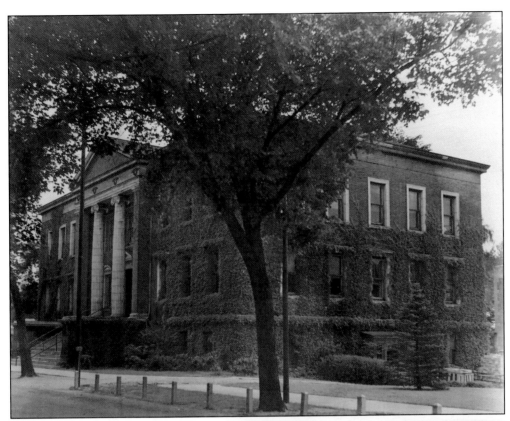

The University of Akron, originally known as Buchtel College, opened its doors in 1872 in a building named Old Buchtel Hall. The university was named for John Buchtel, an Akron industrialist who was the first and greatest supporter of the college. Historically, large tire and rubber corporations such as Goodyear and Firestone had their headquarters in Akron and were closely associated with the university. In 1909, the first courses in rubber chemistry were offered at the university, and the School of Polymer Science was established in 1988. The University of Akron student at right is working with raw rubber.

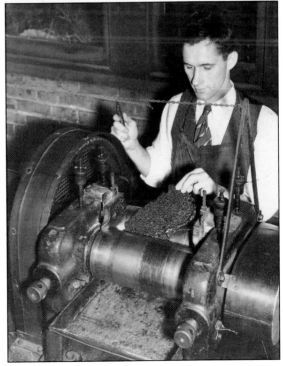

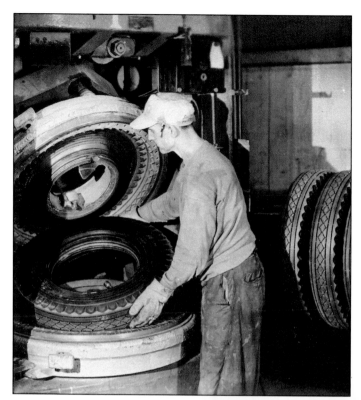

Frank Seiberling founded the Goodyear Tire and Rubber Company in Akron. The man in the photograph is making tires in the 1940s. In the winter of 1839, Charles Goodyear accidentally discovered the process of vulcanization of rubber by adding sulphur and heat. This process eventually led to production of tires as we know them today and to the formation of the Goodyear Company, which borrowed his name. Seiberling converted a strawberry factory on the Cuyahoga River and started making tires in 1898.

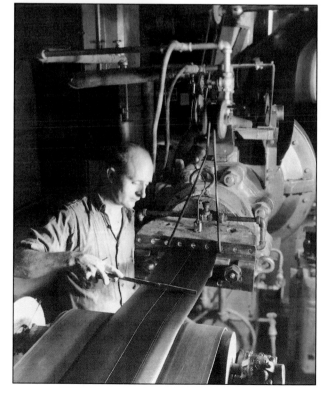

This man is working for the Firestone Tire and Rubber Company. Harvey Firestone started the company in 1900 and had three competitors: archrival Goodyear Tire and Rubber Company, General Tire and Rubber, and B.F. Goodrich. Originally providing tires for wagons, buggies, and other wheeled transportation, Firestone saw the opportunity to provide tires for automobiles. Goodyear and Firestone were the largest providers of automotive tires in North America for 75 years.

Painesville is the county seat of Lake County. The home in this photograph was the residence of Seth Marshall (1815–1883), who gave shelter to fugitive slaves on their way to Fairport Harbor and freedom. The area around Painesville was settled by Gen. Edward Paine in 1800 and was among the first settlements in the Connecticut Western Reserve. The original name of the settlement was Oak Openings, a descriptive name for the scrub oaks and sandy soils of the region. The name was changed to Painesville in 1832 in honor of General Paine. It became a city in 1902.

Founded in 1812, Chardon is the only incorporated city in Geauga County. This view is from Chardon Square Park toward the city center. In July 1868, the entire business district of Chardon was destroyed by fire, including many businesses, offices, meeting halls, and the courthouse. The townspeople rallied and rebuilt the city center. A new courthouse, completed in 1869, and many other buildings constructed after the fire are still used today. The Chardon Square district was listed in the National Register of Historic Places in 1974.

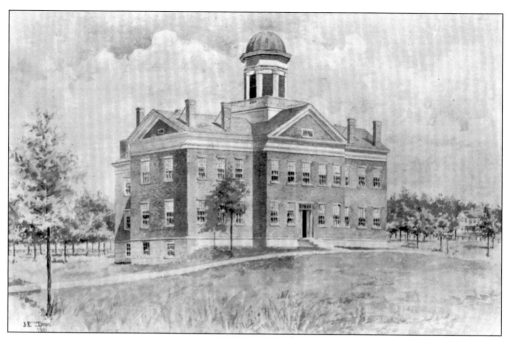

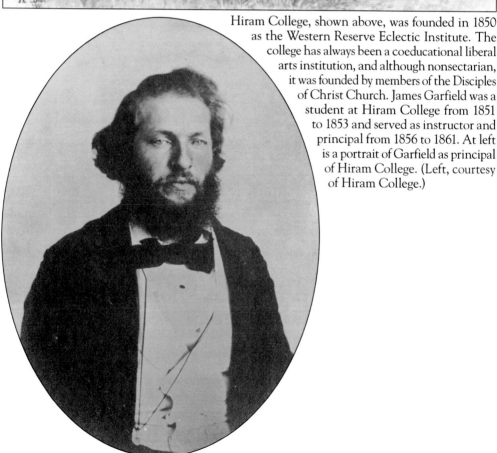

Hiram College, shown above, was founded in 1850 as the Western Reserve Eclectic Institute. The college has always been a coeducational liberal arts institution, and although nonsectarian, it was founded by members of the Disciples of Christ Church. James Garfield was a student at Hiram College from 1851 to 1853 and served as instructor and principal from 1856 to 1861. At left is a portrait of Garfield as principal of Hiram College. (Left, courtesy of Hiram College.)

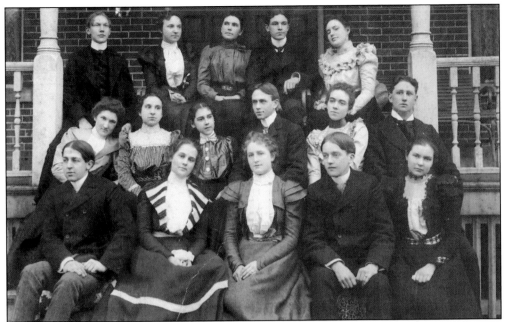

Students gather on the steps of Bowler Hall at Hiram College in 1899 for a photograph. Included is poet Nicholas Vachel Lindsey (top left). Lindsey was born in Springfield, Illinois, and moved to Ohio to study medicine. He attended Hiram College from 1897 to 1900. Lindsey later traveled throughout the United States as a well-known poet and lived until 1931. (Courtesy of Hiram College.)

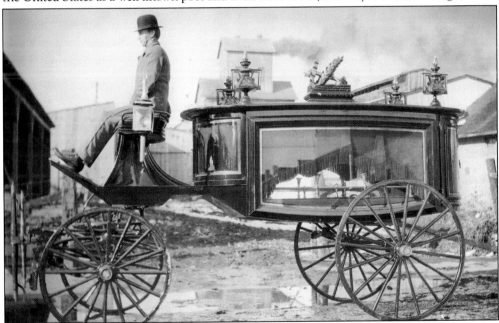

Ravenna, Ohio, is the seat of Portage County and is named for the city of Ravenna, Italy. Benjamin Tappan founded Ravenna in 1799. Later, he would become a general in the War of 1812 and a US senator representing Ohio from 1839 to 1845. The horse-drawn hearse pictured here was made by the Riddle Coach and Hearse Company of Ravenna. US presidents McKinley and Harding were carried in their funeral processions in Riddle hearses.

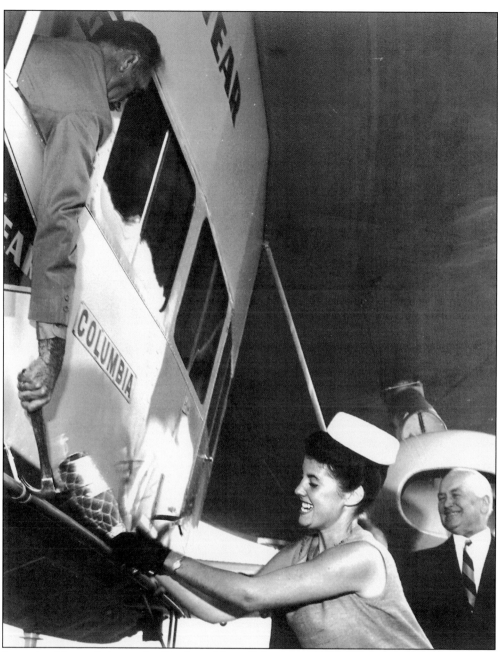

Jacquelyn Mayer christens the Goodyear blimp *Columbia* in 1963. Mayer, from Sandusky, Ohio, won the titles of Miss Vacationland and Miss Ohio and served as Miss America in 1963. The Goodyear Tire and Rubber Company, founded in 1898, expanded its business into lighter-than-air balloons and aircraft. This eventually led to the first Goodyear blimp, built in 1912. In 1916, Goodyear bought land south of Akron near Wingfoot Lake and built the Wingfoot Lake Airship Base, sometimes called the "Kitty Hawk of Lighter-Than-Air."

This drawing of Main Street in Massillon is from *Historical Collections of Ohio* by Henry Howe, published in 1847. First settled in 1812 as the village of Kendal, the name was changed to Massillon in 1826 by its founder, James Duncan, at the request of his wife. The town was named after a French Catholic bishop. The section of the Ohio & Erie Canal connecting Cleveland and the Massillon area was completed in 1828. The town quickly grew and became the port of Massillon in 1832. Massillon incorporated as a city in 1868.

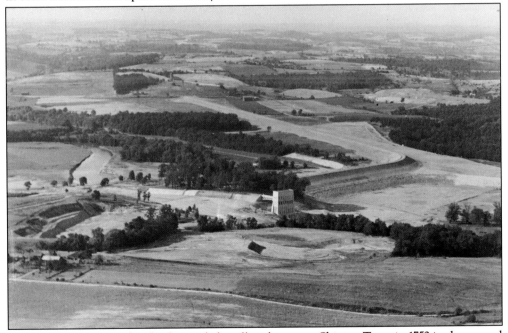

Shingas, a Delaware Indian leader, settled a village known as Shingas Town in 1752 in the general area of what is now the town of Bolivar. Platted in 1830, Bolivar is the northernmost town in Tuscarawas County and developed along with the Ohio & Erie Canal. The photograph shows the Bolivar Dam on Sandy Creek, a tributary of the Tuscarawas River. The dam provides flood control in the Muskingum watershed area.

The American flag is flying at the site of Fort Laurens, a Revolutionary War fort near Bolivar. The fort was built by Lachlan McIntosh in 1778 and was named for Henry Laurens, president of the Continental Congress. The fort was to be a staging area to attack the British garrison at Detroit and to protect American settlers. The Ohio & Erie Canal Towpath Trail passes through the Fort Laurens site, which is also the site of the Tomb of the Unknown Patriot of the American Revolution.

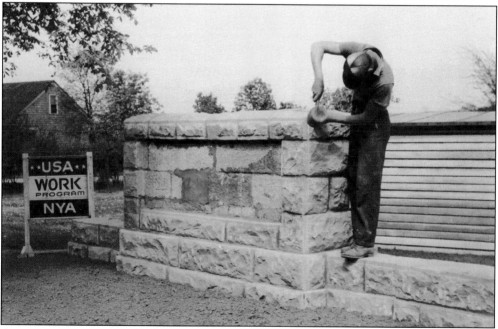

A young man is putting the finishing touches on the stone entrance markers at Fort Laurens Park. The sign next to the entrance indicates that this work is being supported by the National Youth Administration. Part of the Works Progress Administration in the 1930s, the NYA was developed to help young people learn a vocation. It was active from 1935 to 1943.

This view of Zoar village was taken from the hill west of the Ohio & Erie Canal in 1896. The historical village of Zoar was an industrious, self-sufficient community during the mid-19th century. Agricultural products as well as handmade items contributed to the economy of the village. It was founded in 1817 by German separatists who sought religious freedom they could not find in Europe. Zoar is located in the valley of the Tuscarawas River south of Bolivar. The 10 restored German-style structures are part of the Zoar Village State Memorial. Below is a scene on the Ohio & Erie Canal near Zoar. During the 1820s, the State of Ohio required a seven-mile right-of-way through Zoar to build a section of the Ohio & Erie Canal. Zoarites spent several years digging their stretch of the canal.

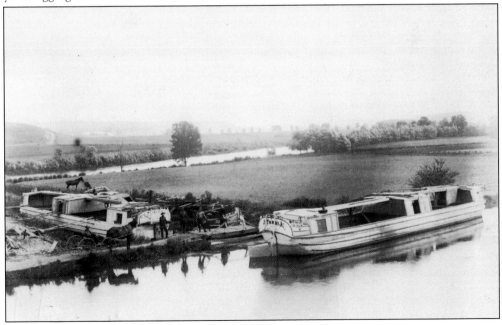

The Tuscarawas River lies just to the west of Zoar. This 1898 photograph was taken looking east across the river toward the village of Sandyville in the background. The Zoarites had traveled from Pennsylvania to Ohio in the autumn of 1817 and were helped on their journey by the people of Sandyville, which was settled just two years before the Zoarites' arrival. After two difficult years, articles of association were signed by members of the community stating that all property and earnings of the members become the common stock of the community.

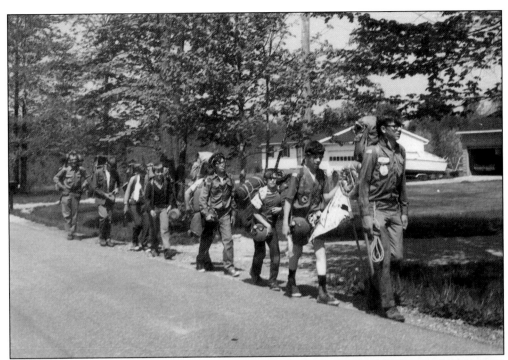

These seven Boy Scouts and their Scout leader are hiking the Buckeye Trail near Big Creek Park just north of Chardon. They appear to be on a backpacking trip. Much of the Big Creek valley was donated to the State of Ohio in 1955. The park now includes 642 acres of steeply rolling terrain. At right, a winter hiker enjoys a campfire in a shelter built by the Geauga Park District to encourage winter use of Big Creek Park. (Both, courtesy of the Geauga Park District.)

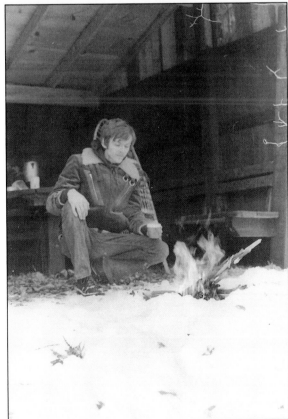

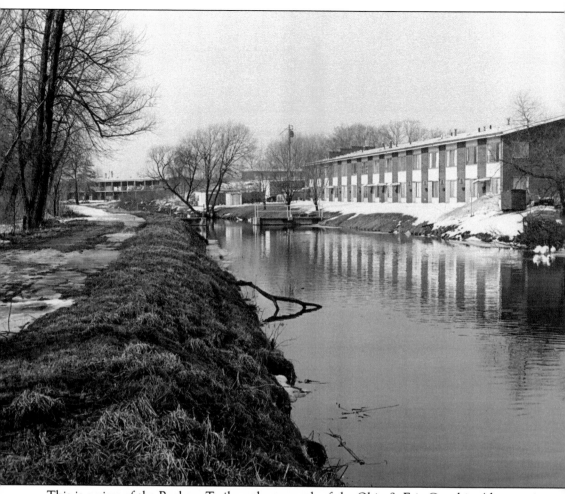

This is a view of the Buckeye Trail on the towpath of the Ohio & Erie Canal in Akron as it passes the canal summit. Young's Restaurant (which was Young's Hotel in the 1820s) is nearby. From this point, streams and rivers flow either north to Lake Erie or south to the Ohio River. (Courtesy of the Buckeye Trail Association.)

Two

DOVER RESERVOIR TO BURR OAK STATE PARK

North of Zoar village, near the Stark County line, the Glaciated Allegheny Plateau landscape starts to change to a region of deep valleys, high forested hills, and winding streams. This part of Ohio is the Appalachian Plateau province, which extends south following the Tuscarawas and Muskingum River watersheds until it reaches the southeastern Ohio hill country, ending at the Ohio River at Marietta. From there, the Appalachian Plateau forms the landscape across southern Ohio as far as Highland County. Due to changes in topography from northeast to southwest, this region may be split into two subregions, the southern Ohio part being covered in the next chapter. The northeastern subregion may be further subdivided. A northern landscape of rolling hills and lakes, many of which are reservoirs managed by the Muskingum Watershed Conservancy District, meets the foothills of the Appalachian Mountains in southern Ohio. The bedrock in this part of eastern Ohio is a series of alternating layers of mostly sandstone, shale, and coal of Pennsylvanian age. This forms a landscape of high ridges and hills and steep-walled valleys.

The Muskingum River and its branches flow about 112 miles, or 60 miles as the crow files, from its headwaters to Marietta. Adena, Hopewell, and Middle Mississippian cultures are represented by mounds and earthworks along its length. The Muskingum River was an important transportation route throughout the 19th century, especially with the introduction of locks and dams in the 1830s. From 1841 to 1888, steamboats had a virtual monopoly on freight and passenger traffic until the railroads arrived after the Civil War. Many stations of the Underground Railroad along the Muskingum carried slaves to freedom.

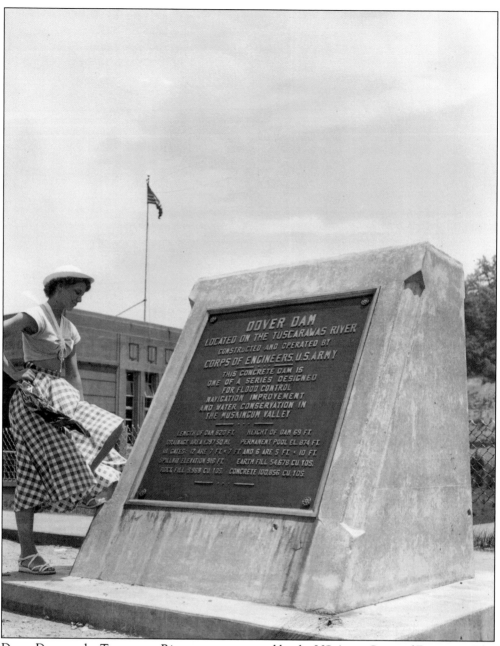

Dover Dam on the Tuscarawas River was constructed by the US Army Corps of Engineers. The concrete dam is 820 feet long and 69 feet high. The Dover Reservoir is one of several built in the 1930s and maintained by the Muskingum Watershed Conservancy District. (Courtesy of the Muskingum Watershed Conservancy District.)

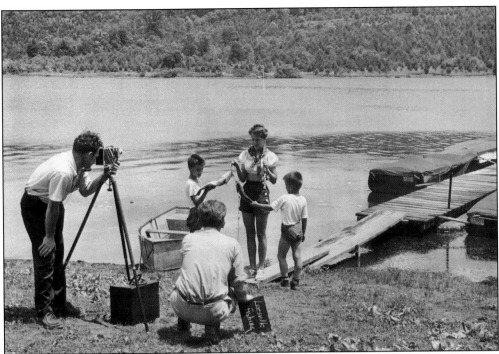

Leesville Dam, completed in 1936, crosses McGuire Creek, a tributary of the Tuscarawas River in Carroll County. Leesville Reservoir has two marinas and several summer camps and is considered the best muskellunge fishing lake in Ohio. The photograph above shows a family after a successful fishing excursion on the lake. Dad is capturing the scene. The boats below are awaiting more fishermen. (Both, courtesy of the Muskingum Watershed Conservancy District.)

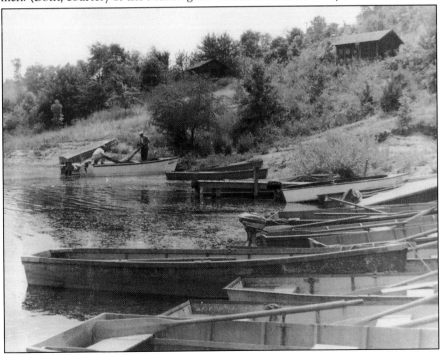

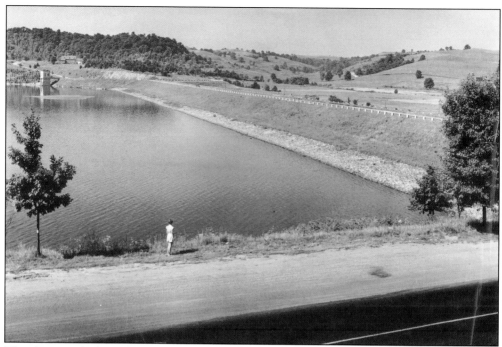

The photograph above shows the Tappan Lake Dam, which was completed in 1936. The Tappan Reservoir lies east of Uhrichsville in Harrison County on Little Stillwater Creek. Two former communities, Laceyville and Tappan, lie inundated at the bottom of the lake. The latter community lent its name to the lake. Below is the swimming beach at Tappan Lake Park. The park and the Tappan Marina offer many activities to visitors. (Both, courtesy of the Muskingum Watershed Conservancy District.)

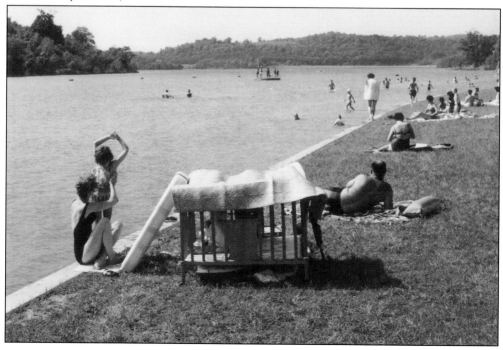

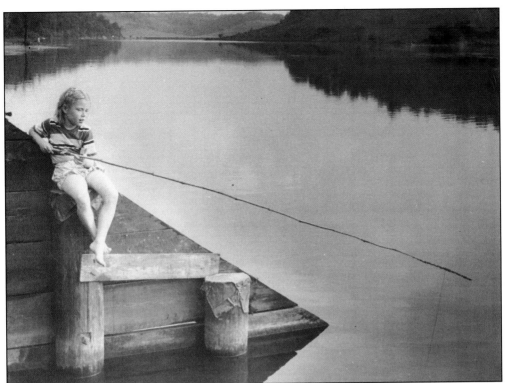

The girl above is enjoying a day at Tappan Lake. Shoreline fishing is popular because of the number of accessible fishing areas. The fishery at the lake is maintained by the Ohio Department of Natural Resources, Division of Wildlife. Tappan Lake is stocked with several species. Below is a view of Tappan Lake at sunset. (Both, courtesy of the Muskingum Watershed Conservancy District.)

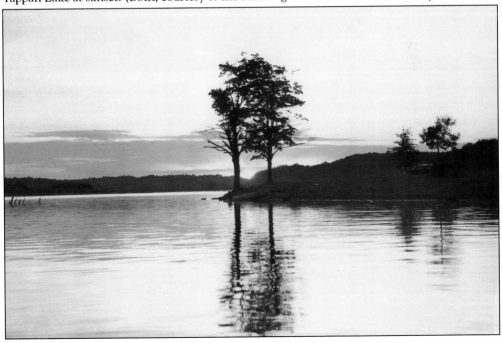

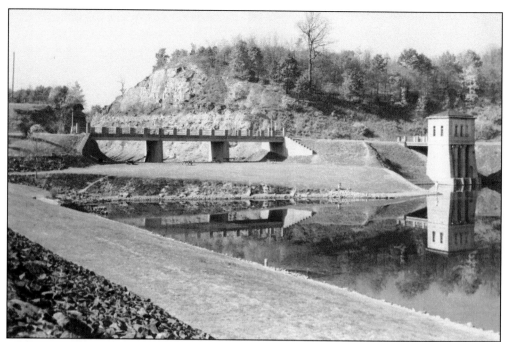

Clendening Reservoir Dam, shown above, was built on the Brushy Fork of Stillwater Creek in the Tuscarawas River watershed. The lake is just east of the village of Tippecanoe in Harrison County. Clendening Lake is the largest undeveloped lake in Ohio. There is little sign of civilization along most of the lakeshore. Clendening Marina, on the south shore of the lake, offers many amenities to those seeking peace and quiet. The view of Clendening Lake below is from Camp Tippecanoe, a YMCA camp at the west end of the lake. (Both, courtesy of the Muskingum Watershed Conservancy District.)

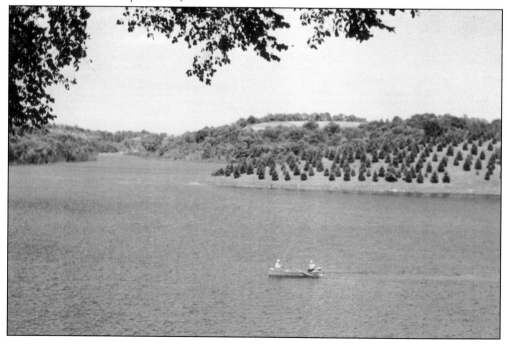

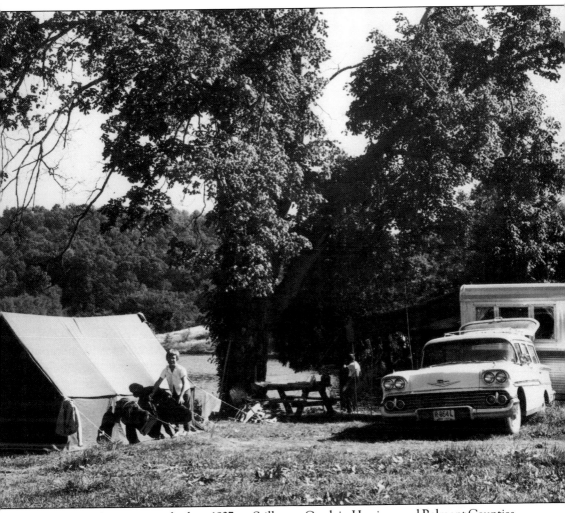

The Piedmont Reservoir was built in 1937 on Stillwater Creek in Harrison and Belmont Counties, near the village of Smyrna. Piedmont Lake is the site of the first US Navy Construction Battalion (Seabee) training center. The Seabees served with distinction in World War II. The family in this photograph is setting up camp at the lake in 1959. (Courtesy of the Muskingum Watershed Conservancy District.)

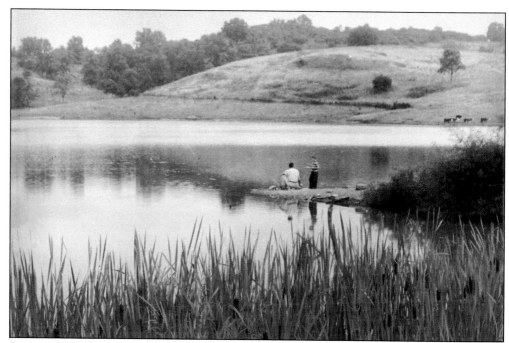

Senecaville Reservoir was constructed in 1938 on the Seneca Fork of Wills Creek in Noble and Guernsey Counties, near the village of Senecaville. The reservoir, also called Seneca Lake, is the southernmost and largest of the lakes managed by the Muskingum Watershed Conservancy District and one of the most popular. Two views of Seneca Lake are shown here. Recreation opportunities are offered by several businesses on the lake. Below the dam is a 37-acre Ohio Department of Natural Resources, Division of Wildlife state fish hatchery. (Both, courtesy of the Muskingum Watershed Conservancy District.)

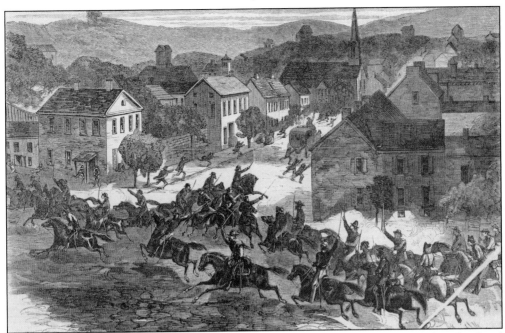

In the summer of 1863, Brig. Gen. John Hunt Morgan and his Confederate cavalry plundered their way across southern Ohio. After leaving Senecaville in Guernsey County, they reached Old Washington on July 24. There, they engaged Union troops in a brief battle. Morgan and his men escaped and moved north, where they were eventually captured in northeastern Ohio near the Ohio River. The community of Old Washington lies along the Buckeye Trail in east central Ohio. This illustration of Morgan's Raiders entering Old Washington was published in *Harper's Weekly* in August 1863.

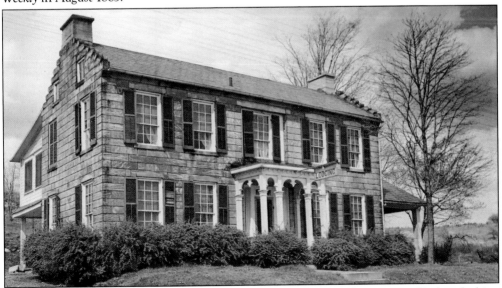

The National Road was approved by Congress in 1806 to allow travelers to cross the Appalachian Mountains. Delayed by the War of 1812, construction started in Maryland in 1815 and traversed Ohio in the 1820s and 1830s. This photograph, taken in 1936, is of a lodging house along the National Road in Old Washington. Today the National Road has been replaced by US Route 40.

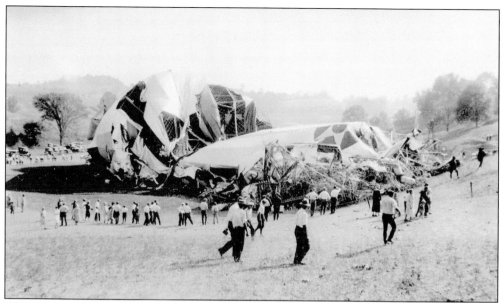

The photograph above shows the wreckage of the USS *Shenandoah*. The *Shenandoah* was the first rigid airship built in America that was filled with helium instead of hydrogen, which is an explosive gas. On September 3, 1925, the airship crashed in a storm over Ava, Ohio, killing many of the crew and the captain, Lt. Comdr. Zachary Landsdowne of Greenville, Ohio. Below is a monument to the *Shenandoah* near Ava.

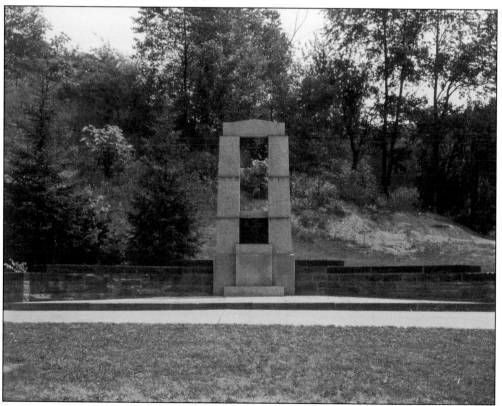

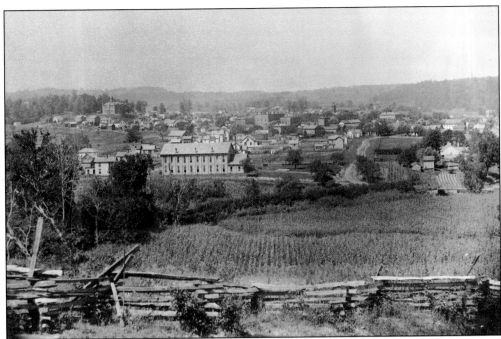

The village of Caldwell lies in an area of southeastern Ohio that remained sparsely populated until the late 19th century. In 1814, residents of Caldwell were drilling for salt water when they struck oil instead. For the next several years, they had no idea of oil's eventual importance and probably considered it a nuisance. When oil did become important in the 1880s, the town prospered. The boom ended in the early 1900s when the oil reserves in Noble County declined.

John Chapman, or Johnny Appleseed, was born in Massachusetts in 1774. He served as a minuteman in the Continental Army during the American Revolution. As a teenager, Chapman apprenticed to an orchardist who managed apple trees. His interest in apple trees rose from this experience and his belief in the symbolic importance of apples. Johnny Appleseed spent his life traveling throughout Pennsylvania and Ohio planting apple orchards. The monument shown here is located near Dexter City.

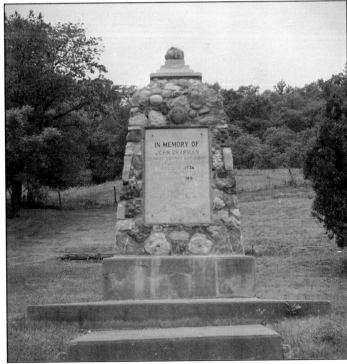

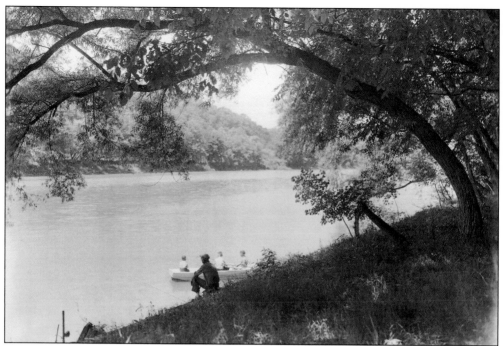

These two photographs are scenes of the Muskingum River in the southern part of the Muskingum watershed. Above, boys fish along the bank of the river in Morgan County upriver from Stockport, while below, barges are being towed near the confluence of the Muskingum and Ohio Rivers. The Muskingum is one of the longest rivers within the state of Ohio. Flowing south from Coshocton to Marietta, the river is 112 miles in length and drains nearly one fifth of the state. Its name is taken from the Native American word *moos-kin-gung* (elk eye river).

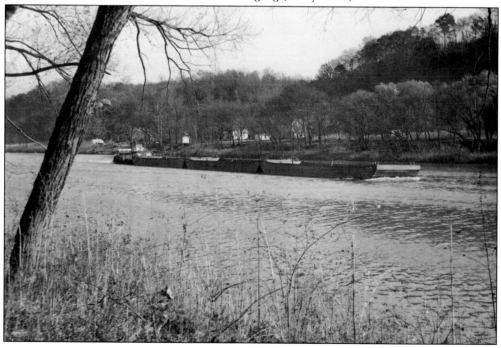

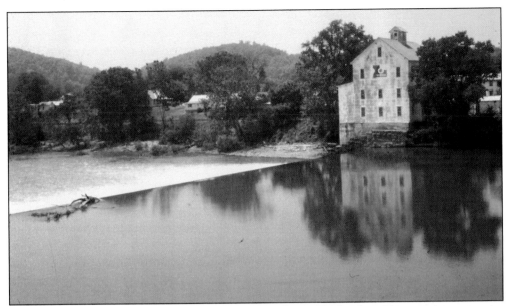

Stockport, Ohio, gets its name from the town of Stockport, England, and because it was a major port for shipping cattle down the Muskingum River. The town is in a region known as the Northwest Territory and was settled in the 1780s and 1790s by veterans of the Revolutionary War. The Stockport Mill served as a gathering place for the community as well as a producer of flour. The dam and mill also generated power for the community. The Buckeye Trail crosses the Muskingum River at Stockport.

The Big Bottom Massacre Monument, shown here, is a 12-foot obelisk that commemorates an attack in the winter of 1791 in which Native Americans killed more than a dozen white settlers on the floodplain of the Muskingum River near Stockport. This incident was part of the Northwest Indian War, which started in 1785, after the American Revolution. It ended with the Treaty of Greenville in 1795, which forced Native Americans to give up their lands south of the treaty line that stretched from Greenville in western Ohio to Fort Laurens.

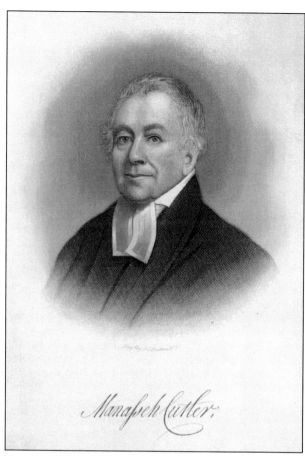

Manasseh Cutler

After a varied and successful career in Massachusetts, including being active in the Revolutionary War as a chaplain and physician, Manasseh Cutler joined several other veterans to form the Ohio Company of Associates. This group negotiated with Congress in 1787 for the right to develop land in the Ohio Country and purchased up to one and a half million acres along the Ohio River. In April 1788, the first group of settlers landed near the confluence of the Muskingum and Ohio Rivers at present-day Marietta. Many of the settlers were veterans who had been paid for their service with land.

On April 7, 1938, the 150-year anniversary of the first settlers' arrival in Marietta was celebrated. As this photograph shows, the participants were dressed as pioneers, Native Americans, and soldiers.

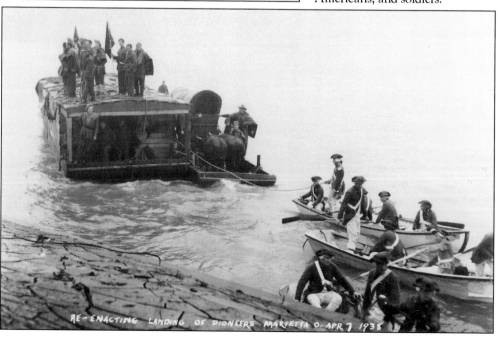

RE-ENACTING LANDING OF PIONEERS MARIETTA O. APR 7 1938

Above is the Ohio Company land office used by Gen. Rufus Putnam to establish the first American settlement on the banks of the Ohio River. Putnam was a Revolutionary War veteran and member of the Ohio Company of Associates. Originally known as Adelphia, the community he founded became Marietta in 1788. To protect the settlement from Native American attacks, a fortification known as Campus Martius was built on the east side of the Muskingum River. The Ohio Company land office is the oldest building in the Northwest Territory and is presently part of the Campus Martius State Memorial. Below is an illustration of Campus Martius. The buildings and structures were completed in 1791.

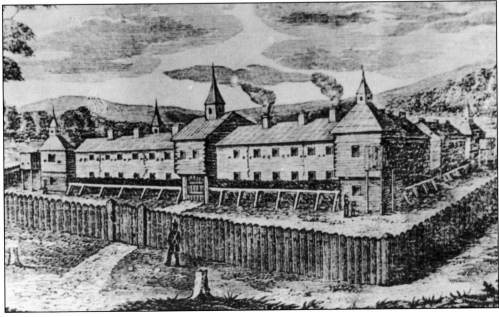

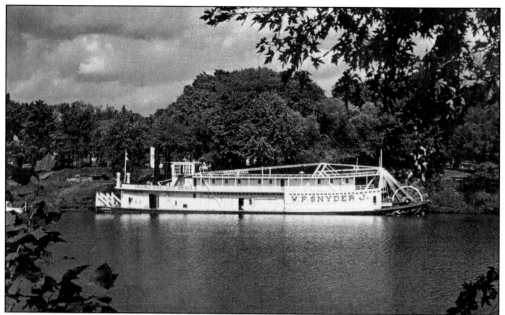

This postcard shows the *W.P. Snyder Jr.* at anchor on the Muskingum River at Marietta. The *W.P. Snyder Jr.* is a stern-wheeled, steam-driven towboat that was built in 1918. In 2003, it was listed in the National Register of Historic Places. Starting in 1824, boats similar to this one carried freight and passenger traffic up and down the Muskingum through 11 locks and dams. As with the Ohio & Erie Canal, river boat traffic gave way to the railroads by the turn of the 20th century.

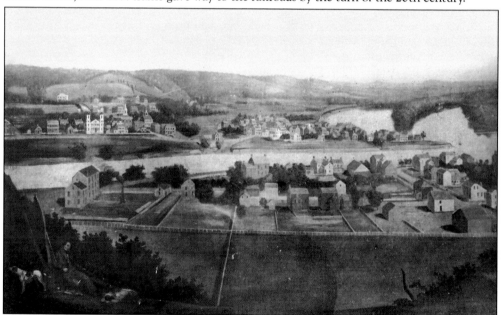

This painting shows Marietta as it looked in 1840. By the beginning of the 19th century, Marietta had become a thriving settlement. Agriculture, trade with eastern cities, and shipbuilding contributed to its growth. In 1840, the population was over 1,800 residents, and the community had several schools, two libraries, and Marietta College. Marietta was later surpassed by other cities when the Ohio & Erie Canal and the railroads were built.

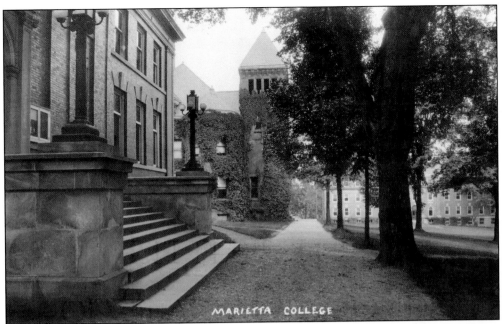

Founded in 1797 as Muskingum Academy, Marietta College was chartered in 1835 as a private liberal arts institution. Before the Civil War, the city and college were abolitionist. Runaway slaves were sheltered at Marietta College, which served as a station on the Underground Railroad.

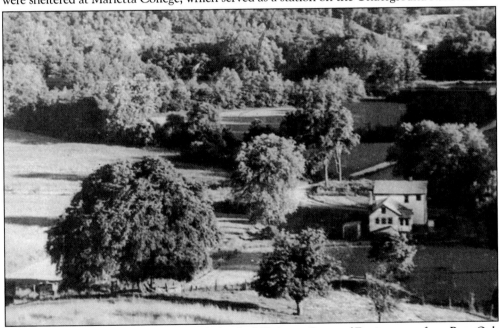

The Tom Jenkins Dam was built in 1950 by the US Army Corps of Engineers to form Burr Oak Reservoir, a multipurpose flood control project. The Sunday Creek watershed extends from the hills north of Corning and flows south into Athens County. The East and West Branches of Sunday Creek join near Glouster and enter the Hocking River at Chauncey. This view overlooks the East Branch of Sunday Creek, where the Tom Jenkins Dam is located. (Courtesy of the Athens County Historical Society.)

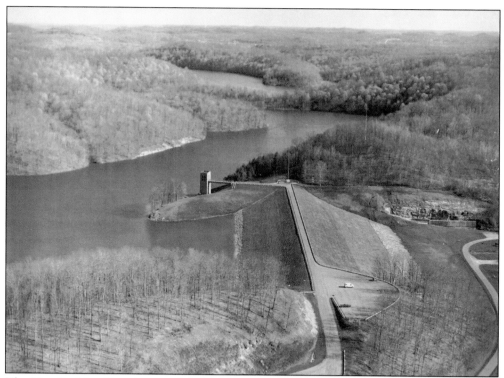

The Tom Jenkins Dam is named for the congressman from the 10th District of Ohio who shepherded the legislation through congress. The dam was built because of destructive floods in the new communities of the Hocking River Basin early in the 20th century as well as record droughts of the 1930s. There was either too much water or not enough. Construction of the dam started in 1948, after the Flood Control Act of 1944 was approved. (Courtesy of the Athens County Historical Society.)

This young lady enjoys a day at the beach at Burr Oak State Park. The park was opened in 1952 and boasts many recreational activities. The area around the park is rich in wildlife and wilderness character. The East Branch of Sunday Creek was largely unaffected by the environmental impacts of the coal mining era during the 19th and early 20th centuries.

Three

LITTLE CITIES
OF BLACK DIAMONDS
TO SERPENT MOUND

The southern and western part of the Appalachian Foothills region of the Unglaciated Allegheny Plateau includes all of southern Ohio as far west as Serpent Mound in Adams County. Moving west across southern Ohio through a landscape of rugged hills and narrow valleys, the Buckeye Trail enters the Little Cities of Black Diamonds micro-region. The bedrock of this area is sandstone and shale beds alternating with coal seams deposited during the Pennsylvanian period. Regional uplift of the Appalachian Plateau brought these coal beds close to the surface, where they could be easily mined. Due to regional tilting of the bedrock toward the east, the bedrock exposed at the surface gets older in south central Ohio.

In Hocking Hills State Park, sandstones exposed in the cliff walls are Pennsylvanian age near the top covering Mississippian age rocks below, which include the recess caves in the park. In the western part of the Unglaciated Allegheny Plateau, the sandstones of Mississippian and Devonian age give way to limestone bedrock of the Silurian period. This is one of the wildest parts of Ohio and home to the Edge of Appalachia Preserve and the Allegheny Escarpment. To the south, the Interior Lowland–Bluegrass province exhibits karst topography and limestone ridges. To the west and north are the till plains of the Glaciated Central Lowlands province.

Native American inhabitants of southern Ohio are documented in the 1700s, although they may have hunted in these lands before that time. The Shawnee, Delaware, and Wyandot tribes set up permanent settlements along the Muskingum and Scioto Rivers, where food was plentiful and river transportation was convenient. In the wild landscape between these rivers, hunting camps were temporary, and all considered the land to be common hunting ground. The advance of European settlers from the east was peaceable at first but became increasingly hostile. These hostilities and the Revolutionary War culminated in the Treaty of Greenville in 1795, when many Native Americans were forced to move west and into northern Ohio above the Greenville Treaty Line.

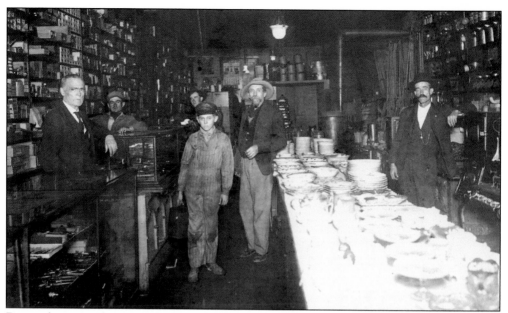

Due to the remote location of coal towns, company stores were essential to coal miners and their families. Young miners, like the boy pictured here, were part of the workforce. Like many company stores in the coalfields of southeastern Ohio, the Sunday Creek Coal Company store in Glouster was a large, well-built, two-story brick building well stocked with general merchandise. China dinnerware seems to be on sale today. (Courtesy of the Athens County Historical Society.)

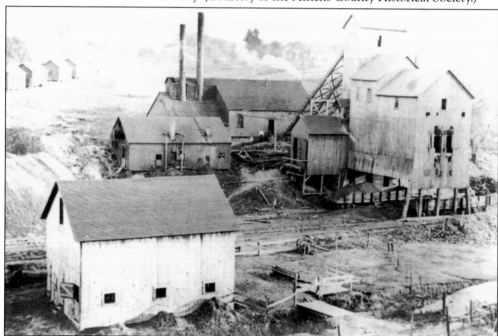

The Phoenix Coal Company mine shown here is one of several in the area around Glouster. The Sunday Creek valley coalfield became an important resource in the 1890s and contributed to the rapid growth of the community. Notice the coal tipple with railroad cars waiting below and a cluster of miners' houses in the upper left. (Courtesy of the Athens County Historical Society.)

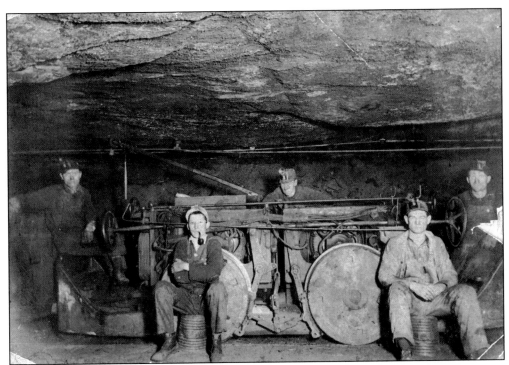

This unusual photograph, taken inside an active coal mine, shows four miners and their foreman resting during their shift. From left to right are Frank Moody, Joe Moody, Alfred Howard, Andy Williams, and foreman Roy Judson. Notice the carbide lamps on their hats. The mine is near the town of Glouster, which was platted in 1882 as Sedalia. The name was changed to Glouster in 1886. (Courtesy of the Athens County Historical Society.)

Murray City was incorporated in 1891, several years after coal was first mined there. The town grew rapidly and, due to its picturesque setting, became a good place to settle and open businesses such as the Lunt and Son Grocery Store, pictured here. By 1907, Murray City had a population over 2,000. (Courtesy of the Little Cities of Black Diamonds Council.)

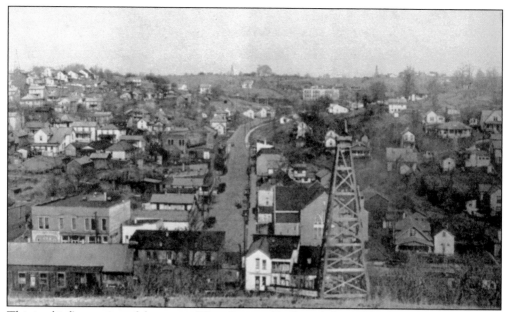

This is a bird's-eye view of the town of New Straitsville. Founded in 1870, the town produced coal for the New Straitsville Mining Company until 1884. Notice the oil drilling rig in the foreground. The oil boom in Ohio in the late 19th century was more of a historical footnote, although in the 1890s, Ohio was the nation's leading oil producer. An oil boom hit New Straitsville itself in 1910. Both oil and natural gas are still produced in Ohio. (Courtesy of the Athens County Historical Society.)

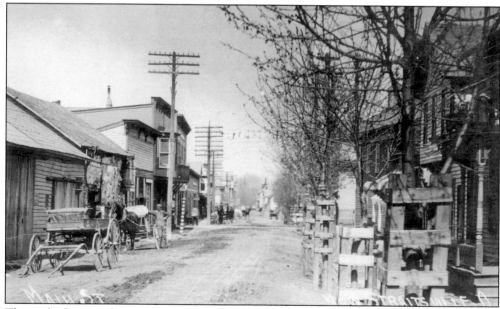

This early photograph was taken looking down Main Street in New Straitsville. Although horse-drawn carriages and wagons were still the main source of transportation, New Straitsville had become a prosperous and attractive place to live by 1909. Many coal mines, the Baltimore & Ohio and Hocking Valley Railway Companies, an iron furnace, and a brick manufacturing company all added to the commerce of the city. (Courtesy of the Athens County Historical Society.)

The miner in this photograph is wearing the protective firefighting equipment of the time. The New Straitsville mine fires reportedly started on November 13, 1884. A labor dispute between the miners and the coal company resulted in a miners' strike. After several months, mine workers sabotaged the mine by pushing burning coal cars into it, setting it on fire. As a result, the mine closed. (Courtesy of the Athens County Historical Society.)

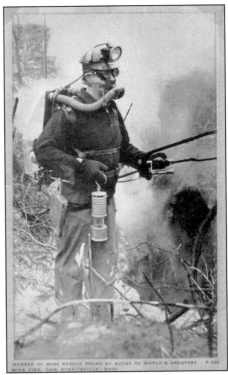

MEMBER OF MINE RESCUE SQUAD AT SCENE OF WORLD'S GREATEST F-333
MINE FIRE, NEW STRAITSVILLE, OHIO

The man in this photograph, possibly a Works Progress Administration employee, is reading the "Caution Mine Fire" sign on a road outside of New Straitsville. This photograph was taken in 1938. Two years earlier, the Works Progress Administration began work to stop the spread of the mine fires, with 350 men employed on the project. Mine fires affected coal deposits in Hocking and Perry Counties covering more than 200 square miles. In 2003, smoke from the fires emerged in Wayne National Forest, 119 years after the fire began.

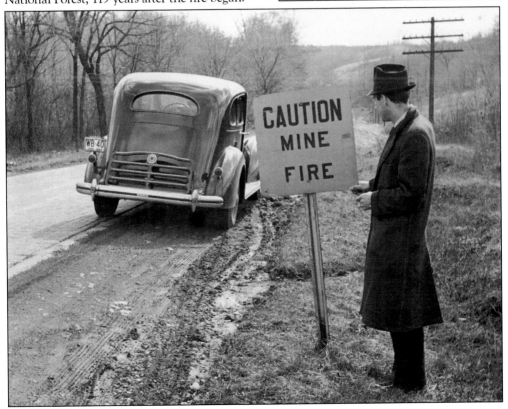

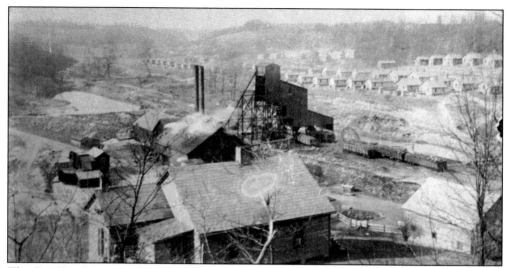

The San Toy Mine No. 2, above, was one of two mines operated by the Sunday Creek Coal Company in San Toy. Company houses can be seen in the background. The town of San Toy was created in 1900 to serve the mines. From then until the late 1920s, the town prospered, and the miners were well cared for. San Toy also got a reputation as a rough town where murder and mine accidents were common. In the midst of this, there were families and children. (Courtesy of the Little Cities of Black Diamonds Council.)

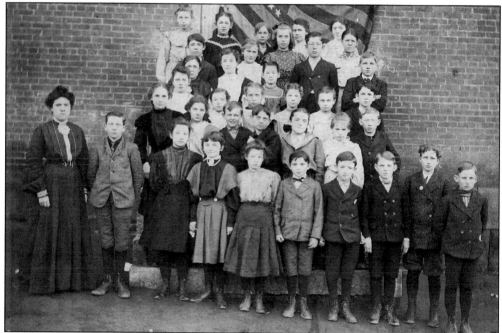

Students and their teacher are shown (possibly at graduation) at the Walnut Street School in Shawnee. Everyone is dressed in their Sunday best. From its founding in 1872 until the early 1900s, Shawnee grew into a booming coal-mining town with many businesses as well as churches and schools. The population rose to more than 4,000. The bust came in the 1930s, when lands surrounding the town were abandoned. The federal government then bought the land and included it in Wayne National Forest. (Courtesy of the Little Cities of Black Diamonds Council.)

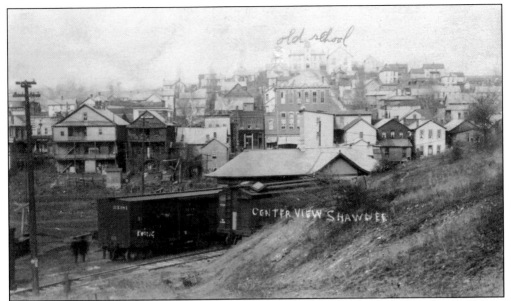

Shawnee in 1909 looked similar to many other coal towns in southern Ohio. Two buildings that made Shawnee, in Perry County, unique were the old schoolhouse at the top of Shawnee Hill (demolished in 2002) and the Tecumseh Theater, completed in 1908. The theater has been through many changes over the years, from silent films to big bands, and it is currently being renovated. (Courtesy of the Athens County Historical Society.)

This is a view of McCuneville looking north towards New Lexington. Lying just west and north of Shawnee, McCuneville was established at the same time in the late 19th and early 20th centuries as many other coal towns in the region around Perry County. To the left is the McCuneville Hotel as it looked in 1962. Next to it is the general store and post office. (Courtesy of the Little Cities of Black Diamonds Council.)

In the 19th and early 20th centuries, coal was extracted from the earth by tunneling into a hill (drift mining) or digging vertical shafts to access coal from deep underground. During the 1940s and World War II, surface mining or strip mining allowed coal close to the surface to be mined more quickly and inexpensively for the war effort. The devastation of such mining on the landscape caused great concern until the passage by Congress in 1977 of the Surface Mining Control and Reclamation Act.

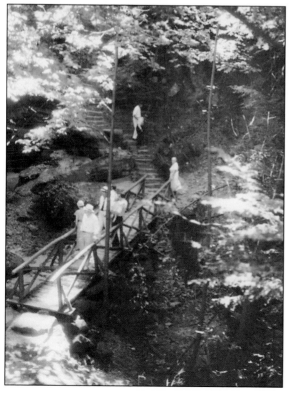

Throughout the 1920s in Ohio, many unprotected forest areas with unique geologic features were designated as state forests and forest parks. Hocking Hills State Park was created at this time. During the Great Depression of the 1930s, the Civilian Conservation Corps (CCC) and the Work Progress Administration were organized to provide jobs for disadvantaged youth. From 1933 to 1935, CCC camps in Ohio employed men to revitalize forest areas and build roads, bridges, trails, shelter houses, and lodges. Many of the structures in Hocking Hills State Park were built at that time. The Buckeye Trail now passes through many of these state parks and forest areas.

Rock House is a unique attraction in Hocking Hill State Park. The only true cave or arch in the Hocking Hills, Rock House is 200 feet long and about 25 feet wide, with a roof more than 20 feet high. The interior is lit by windows eroded in the wall. Rock House has been used by generations of Native Americans as a shelter and later earned the nickname of "Robber's Roost" when it was used as a hideout by more unsavory visitors.

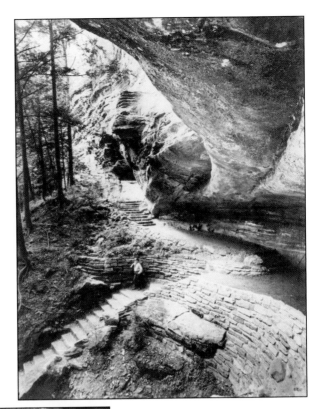

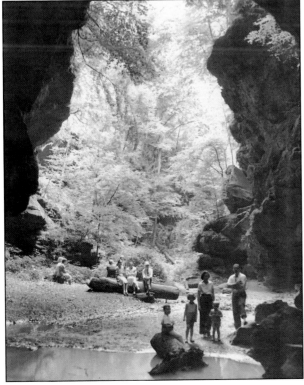

Considered one of the deepest gorges in Ohio, Conkle's Hollow State Nature Preserve is part of the Hocking Hills State Forest area and is about one mile from the Buckeye Trail. Vertical cliffs rise 200 feet above the valley floor, which provides hikers with a cool, shaded walk along the creek. Conkle's Hollow got its name from W.J. Conkle, who carved his name and the date 1797 on the sandstone wall of the gorge.

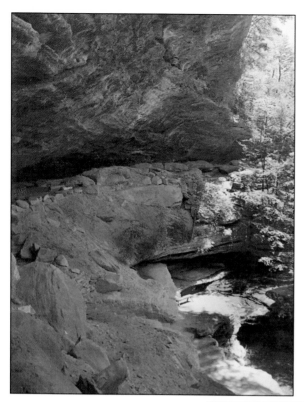

One of the most popular attractions of the Hocking Hills area is Old Man's Cave (shown here). Open to the sky, the cave is known as a recess cave and lies within a gorge one half-mile in length. The gorge cuts through the 150-foot thickness of the Black Hand sandstone that forms the bedrock of the region. Old Man's Cave gets its name from Richard Rowe, who moved to the Hocking Hills region in 1796. He lived out his life in the gorge and is buried beneath the ledge of the main recess cave.

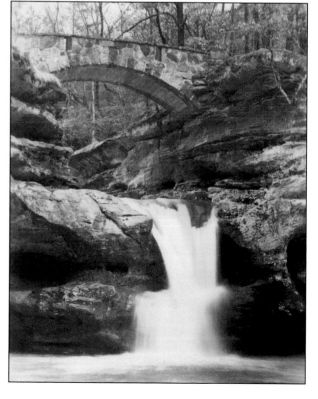

At the northern end of Old Man's Cave, a six-mile stretch of the Buckeye Trail is designated the Grandma Gatewood Memorial Hiking Trail. The trail connects Old Man's Cave to Cedar Falls and Ash Cave at the southern edge of Hocking Hills State Park. The waterfall at the start of the Grandma Gatewood Trail is known as the Upper Falls of Old Man's Cave.

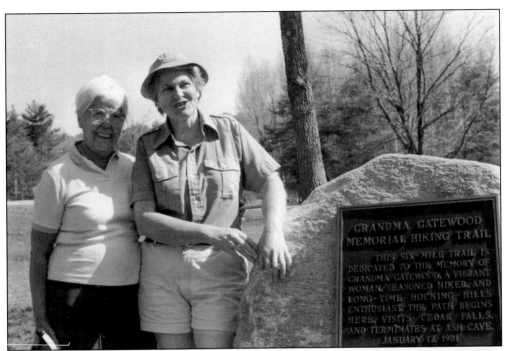

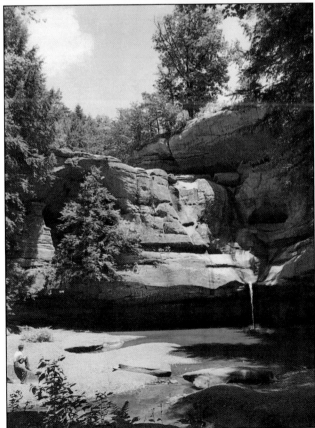

This photograph was taken in April 1984. Shown at the memorial plaque are Buckeye Trail Association president Emily Gregor (left) and Ann Quadrano. Emma R. "Grandma" Gatewood was a longtime member and volunteer of the Buckeye Trail Association and the first woman to solo thru-hike the Appalachian Trail in 1955 at the age of 67.

Cedar Falls, shown here probably in the dry season of late summer, lies downstream from Old Man's Cave where Old Man's Creek joins with Queer Creek. The Queer Creek valley is one of the most primitive places in the Hocking Hills. Cedar Falls is the largest waterfall by volume in the park. This waterpower was used in the mid-19th century by a gristmill to grind grain. The abundant hemlock trees in the valley were mistaken by settlers for cedar trees, thus the name.

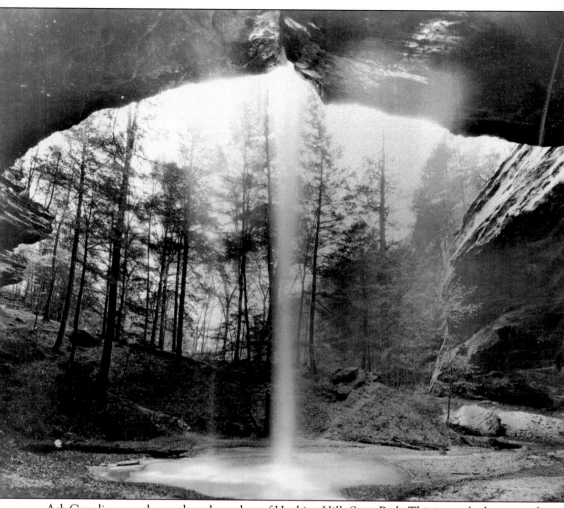

Ash Cave lies near the southern boundary of Hocking Hills State Park. This image looks outward from the rear of the recess cave past the waterfall. The cave measures 700 feet from end to end and 100 feet from the back of the cave to the waterfall, which drops 90 feet to its base. Ash Cave was used as a habitation and workshop by Native Americans for hundreds of years and is named for the large amount of campfire ashes found on the cave floor.

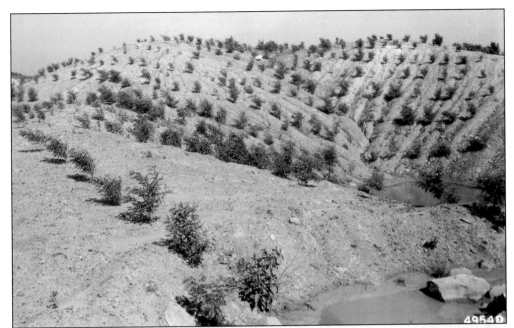

Wayne National Forest, the only national forest in Ohio, is comprised of nearly 1,000 square kilometers of land in the rugged Allegheny Plateau of southeastern Ohio. By the 1920s, the original forests of the area had been largely cut down and the hills extensively farmed. The Great Depression of the 1930s and severe soil erosion caused the local economy to collapse. The photograph above shows tree seedlings planted on an eroded hillside in the region, while the photograph at right shows a mother and her son examining a 10-year-old pine sapling. (Both, courtesy of Wayne National Forest.)

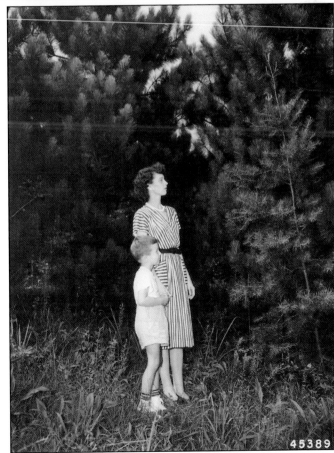

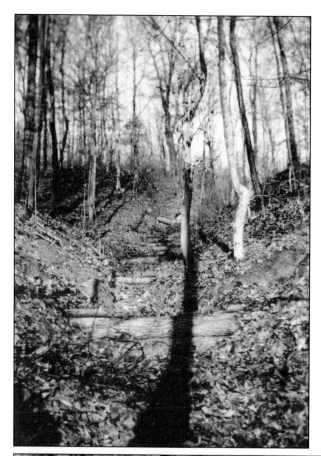

The US Forest Service and the CCC did most of the work restoring the forest. Restoration began by building timber check dams across gulleys to reduce erosion of topsoil. The check dams, shown in these two photographs, reduce the velocity of water flow, causing sediment to settle. The two men below are members of the Nelsonville CCC camp. (Both, courtesy of Wayne National Forest.)

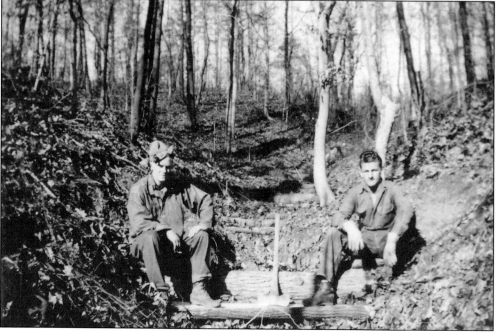

Another CCC member is planting one of many thousands of seedlings needed to stabilize the eroded slopes in Wayne National Forest. Red pine seedlings, grasses, and legumes were planted to renew the soil in many areas of Wayne National Forest. (Courtesy of Wayne National Forest.)

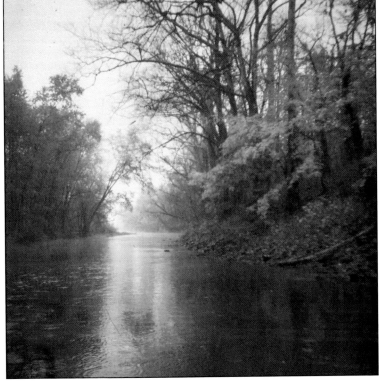

This is a misty view of Salt Creek Narrows within Tar Hollow State Park. The park gets its name from pine tar, derived from the native pitch pines in the region. Pine tar was useful for making medicinals and lubricants for pioneer families. Surrounding the state park is Tar Hollow State Forest, which originated with the Ross-Hocking land utilization project in the 1930s. Tar Hollow became a state park in 1958.

This is a view of Mount Logan from Scioto Trail State Forest. Mount Logan lies on the Appalachian Escarpment, which stretches across the midsection of Ohio and helps form the edge of the Appalachian Plateau. While the foothills of the Appalachian Mountains rise to the east, glaciated plains extend to the north and west. Mount Logan forms the backdrop of the Great Seal of Ohio. First depicted in 1803, the image on the seal was modified to its present form in 1996.

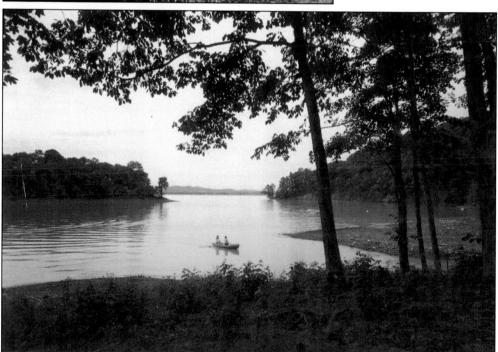

Rising from its headwaters in west central Ohio, the Scioto River flows south through Columbus, where it collects the waters of the Olentangy River, and then meets the Ohio River at Portsmouth. Although more than 230 miles in length, the Scioto River is too small for commercial shipping. Its main economic value is in recreation and as a source of drinking water. This photograph shows two men in a rowboat enjoying the day.

Located just west of the Scioto River and south of Chillicothe is Scioto Trail State Forest. This photograph shows the landscape in winter. The forest is named for the Native American trail that led south from what is now Chillicothe to Portsmouth on the Ohio River. During World War I, the area was used as an artillery range. The CCC built most of the roads, lakes, and recreational facilities in the forest in the 1930s.

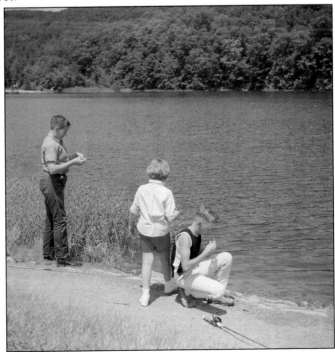

Pike Lake State Park is near the eastern edge of the Appalachian Plateau in a densely forested and remote part of Pike County. The present park was built by the CCC in the 1930s. Corps workers dug Pike Lake by hand, built fire towers and access roads, and planted hundreds of pine trees. The area became a state park in 1949. This group of children is shown fishing at Pike Lake in the 1960s.

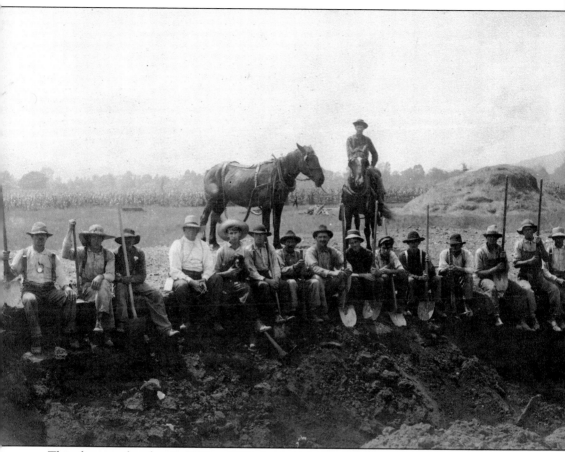

This photograph, taken in 1906 or 1908, shows visitors at the Seip Mound excavation area. Seip Mound is the second largest earthen mound built by the Native American Hopewell Culture (100 BC–AD 500). The large Seip Mound and a smaller mound known as the Seip Conjoined Mound lie within a group of geometric earthworks. The group consists of a large semicircular enclosure surrounding the mounds connected to a smaller circular enclosure and a square enclosure. The complex covers 121 acres.

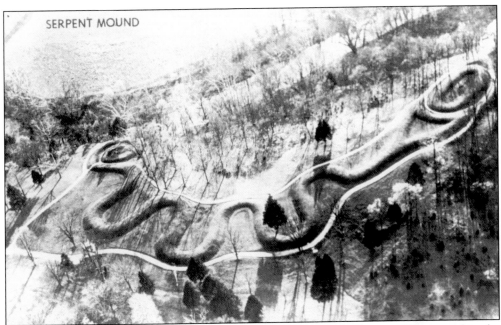

SERPENT MOUND

Picturesque Adams County in southeastern Ohio is the site of the largest effigy mound in the United States. Serpent Mound (above) lies along the Buckeye Trail in a preserve managed by the Arc of Appalachia Preserve System and the Ohio History Connection. Representing an uncoiled snake, Serpent Mound is thought to have been built by the Adena Culture about 300 BC for reasons as yet unknown. One quarter of a mile in length, the mound is encircled by a walking trail. An area surrounding Serpent Mound is known as the Serpent Mound Cryptoexplosion Structure. Evidence suggests that a meteorite impact was responsible for the crater. Serpent Mound and other effigy mounds in Ohio are slated to become world heritage sites.

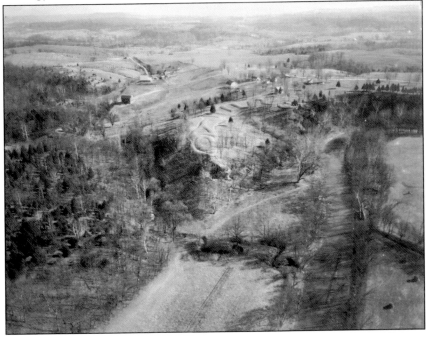

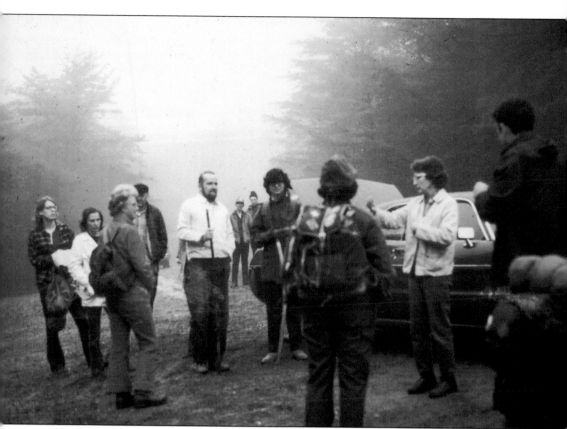

These hikers have met in the parking lot of Crane Hollow State Nature Preserve on what looks to be a foggy morning. Although the preserve is owned and operated by a private nonprofit corporation, 1,286 acres are open to hikers by permit.

Four

BENTONVILLE TO DELPHOS

The Buckeye Trail, which follows a winding path through the Unglaciated Appalachian Foothills, crosses into the glaciated Central Lowlands province near Bentonville just north of the Ohio River at Eagle Creek. The Central Lowlands cover a large part of western and central Ohio and extend north as far as Delphos near the Auglaize River.

A large structural feature known as the Cincinnati Arch extends across western Ohio from the Cincinnati area north to the Toledo area. Throughout the Paleozoic era, regional uplift along the arch resulted in extensive erosion exposing older Paleozoic Silurian and Ordovician limestone rocks. Over time, erosion of the limestone bedrock produced a relatively flat plain compared to much of eastern Ohio.

When the Pleistocene epoch began, about two million years ago, there was little resistance to the advancing lobes of the continental glaciers. The resulting landscape was covered by sands, gravels, and clays of glacial till left behind as the glaciers melted. The till deposits, which became glacial soils of great fertility, were shaped by the action of glacial ice into moraines, or arcing ridges. These, along with other glacial landforms, give the Central Lowlands province its topography.

The Great Miami River, which drains much of the western part of the Central Lowlands, flows south 160 miles from its headwaters at Indian Lake in Logan County and joins the Ohio River at Cincinnati. The Miami & Erie Canal follows the Miami River watershed north until it meets the Auglaize River watershed. The Miami River valley, similar to the Muskingum River valley, has a long history of prehistoric Indian cultures followed by historic tribal cultures. The Miami valley also played an important role in the Underground Railroad in the 1860s.

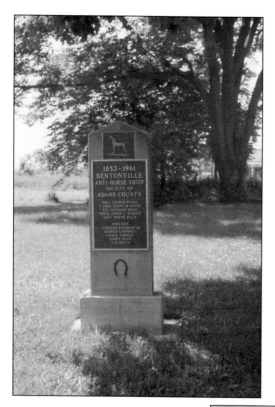

In the mid-19th century, horse theft was widespread in Ohio. Horses were valuable for transportation and farming, so stealing them was a serious offense. To protect the community, a vigilante group known as the Bentonville Anti–Horse Thief Society was formed. Still the oldest continuously operating group established for this purpose, the society is now a social club with members from across the United States. Membership is open to anyone for a onetime fee of $1. The photograph shows the monument to this unusual society.

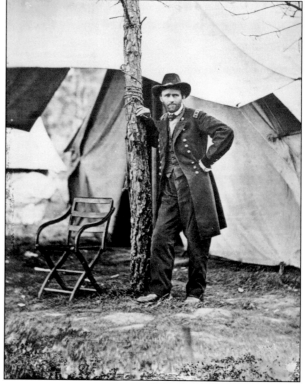

Hiram Ulysses Grant, later Ulysses S. Grant, was born in Point Pleasant on the Ohio River in 1822. This photograph shows General Grant in uniform during the Civil War. After being promoted to the rank of general, Grant was granted command of the Union army by Pres. Abraham Lincoln. In 1868, Grant was elected the 18th president of the United States.

The view above overlooks the Ohio River from Rankin Hill near the town of Ripley. In the 1860s, fugitive slaves would cross the river here from Southern states and be hidden and helped by John Parker, an agent of the Underground Railroad. Parker, who grew up as a slave, eventually bought his freedom and became a successful businessman and inventor. Below is the John Parker House, a designated national historic landmark.

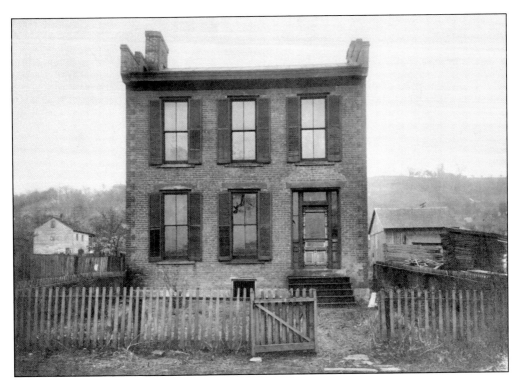

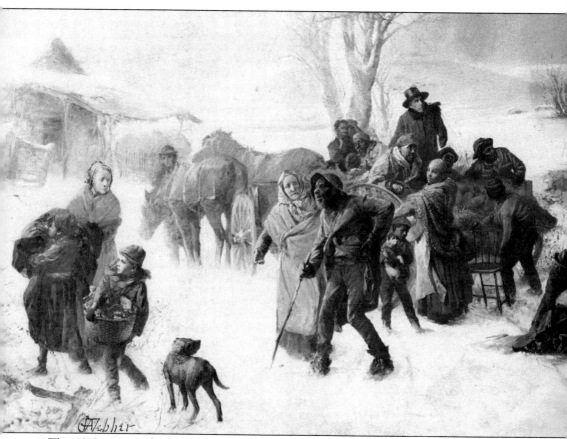

This 1893 painting depicts Levi and Catherine Coffin receiving a group of fugitive slaves outside of Cincinnati. The painting was presented at the World's Columbian Exposition in Chicago. The Fugitive Slave Law of 1850 allowed slave owners to recapture fugitive slaves even if they had moved to a free state. To find freedom, African Americans had to leave the United States. Many people throughout Ohio provided safe houses to help fugitive slaves find their way north to Canada.

The Cincinnati house above was a station of the Underground Railroad, a system of hiding places and safe houses to aid runaway slaves in their quest for freedom. Many slaves found refuge in Ohio, while others escaped to places outside the United States. Many cities in Ohio, and at least eight cities along Lake Erie, helped former slaves move north into Canada. There may have been approximately 3,000 miles of Underground Railroad in Ohio. The photograph below shows an opening in the back porch of the house where slaves may have been hidden.

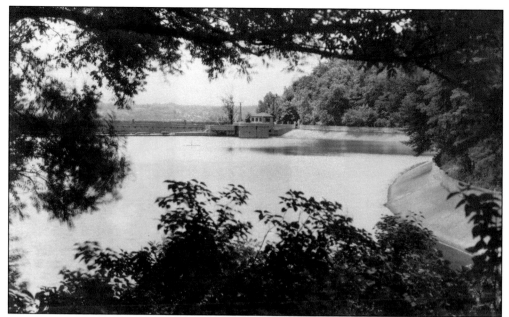

Eden Park overlooks the Ohio River valley. The park is located in the Mount Adams neighborhood of Cincinnati and marks the southern terminus of Ohio's Buckeye Trail. Covering 186 acres, it is home to the Cincinnati Art Museum, the Cincinnati Art Academy, the Eden Park Conservancy, the bronze *Lupa Romano* wolf statue, the Navigation Monument, and the Spring House Gazebo, the oldest structure in a Cincinnati Park. The original name of Eden Park was the Garden of Eden. This photograph was taken from the south end of Mirror Lake in the park.

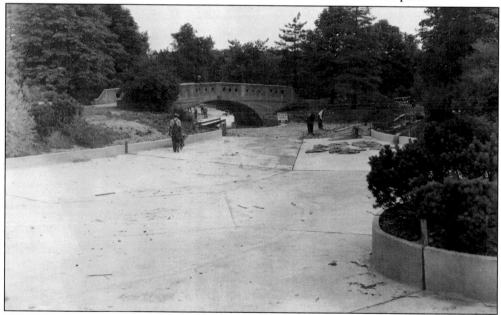

This is a construction site at Eden Park in the 1930s. The park grew from a series of land purchases and was bought by the City of Cincinnati in 1869 from Nicholas Longworth, a prominent landowner. He had called his estate the Garden of Eden and used the land as a vineyard. Part of the name was retained for Eden Park.

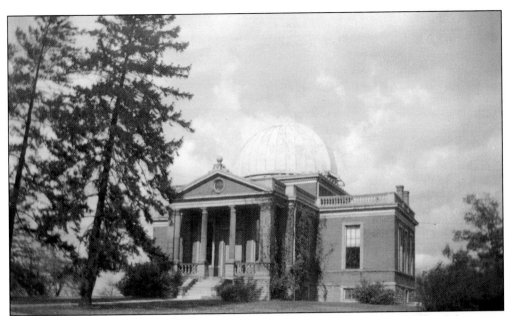

Pictured here is the 1904 Cincinnati Observatory building on Mount Adams, formerly known as Mount Ida. In 1842, Nicholas Longworth donated part of his land to the Cincinnati Astronomical Society for an observatory. Pres. John Quincy Adams gave the dedication address and laid the cornerstone for the new observatory. Mount Ida was renamed Mount Adams in his honor.

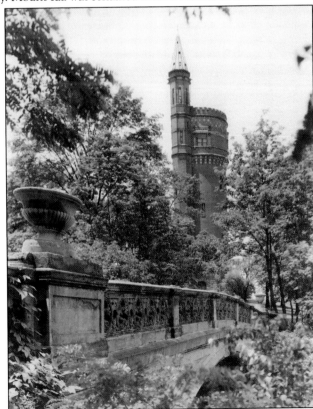

One of the most prominent features of Eden Park is the Eden Park Stand Pipe (shown here). The stand pipe is a cylindrical water tank with an octagonal turret attached. Built in 1894, the structure is 172 feet high and is Romanesque Revival in style. The City of Cincinnati now uses it as a communications platform.

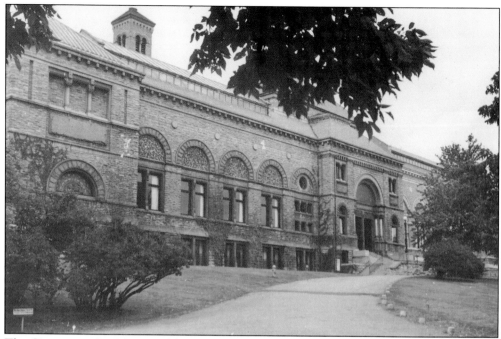

The Cincinnati Art Museum (above) opened in 1886, soon becoming one of the better art museums in the United States. Romanesque Revival in style, the museum has in its collections art from the last five millennia as well as works from local artists. Below is a view of the interior of the Palm House at the Eden Park Conservatory. The central waterfall is surrounded by tropical plants and trees imitating an equatorial rain forest. The conservatory was built in the Art Deco style and opened to the public in 1933.

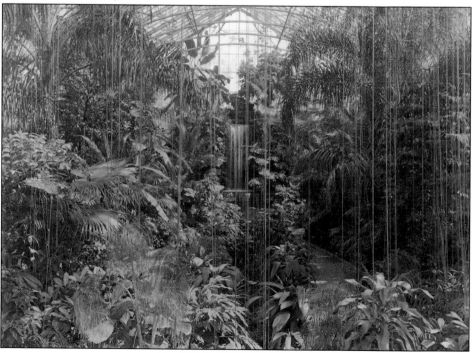

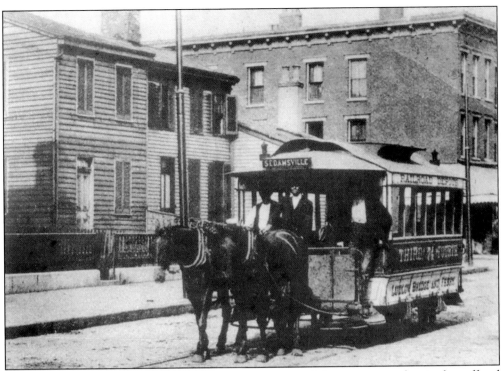

This horse-drawn streetcar in 1880s Cincinnati was one of the many ways the city has offered public transportation to its citizens. Cincinnati, founded in 1788, was the first major American city to be founded after the American Revolution and the first major inland city in the United States. Early in the 20th century, the shift from steamboats to railroads caused Cincinnati to be surpassed by cities like Chicago. The 1937 photograph below shows a man selling the *Cincinnati Post* on a busy sidewalk. The headline reads "Report Many Die in Kentucky Flood."

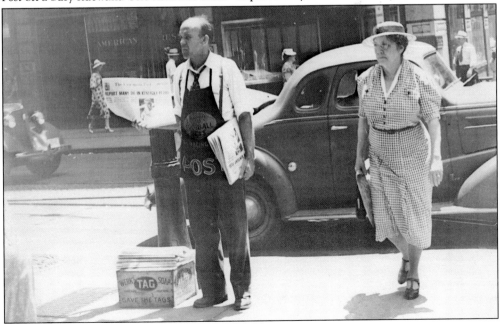

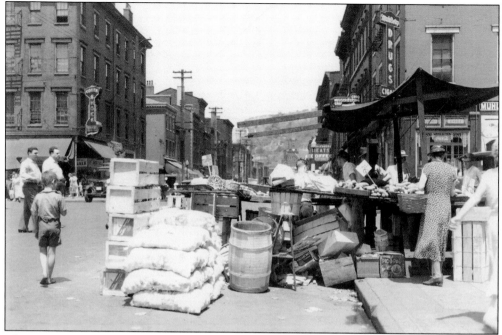

This Cincinnati street scene is a view of the Findley Market, Ohio's oldest surviving municipal market. The market opened in 1855 on land donated to the city by Gen. James Findley and Jane Irwin Findley. The Findley Market is listed in the National Register of Historic Places. This image was produced by the Works Progress Administration under Franklin D. Roosevelt in the 1930s.

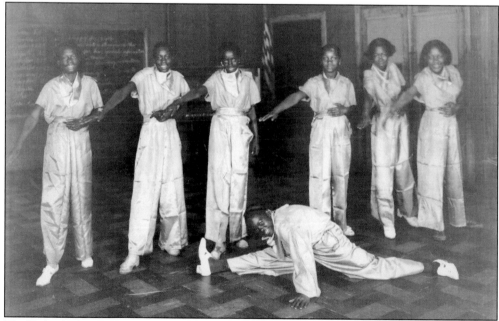

The Federal Theater Project was a program to fund live artistic performances and entertainment during the Great Depression. The programs were sponsored by the Works Progress Administration and enabled many Americans to see live theater for the first time. This photograph of a Federal Theater Project African American dance team was taken in Cincinnati in 1936.

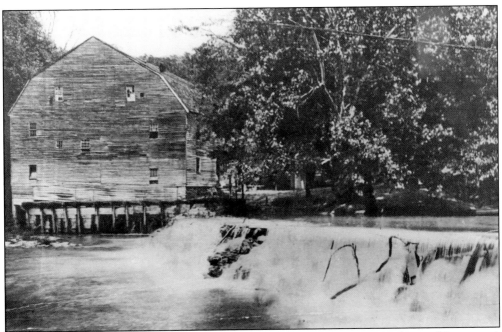

Milford sits along the Little Miami River on the Buckeye Trail as it moves north out of Cincinnati. Milford gets its name from "mill ford," as it was the first place to ford the Little Miami River north of the Ohio River and the only way for Milford residents to reach the mill shown here. The name of the village was changed in 1811 from Hageman's Mill to Milford after John Hageman, one of the original settlers and the original owner of the mill, moved to Indiana.

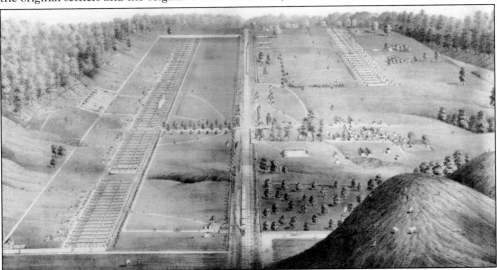

Camp Dennison is 16 miles northeast of Cincinnati along the Little Miami River. Strategically located near the Ohio River and the Little Miami Railroad, the camp was built as a training site and later served as a hospital for soldiers fighting in the Civil War. Named for Gov. William Dennison, the camp was active between 1861 and 1865. During this period, trainees from the camp helped defend Cincinnati and the railroad from Gen. John Hunt Morgan and his raiders. Three years later, at a reunion at Camp Dennison, veterans of the 54th Ohio Volunteer Infantry, Company K, gathered for a group portrait.

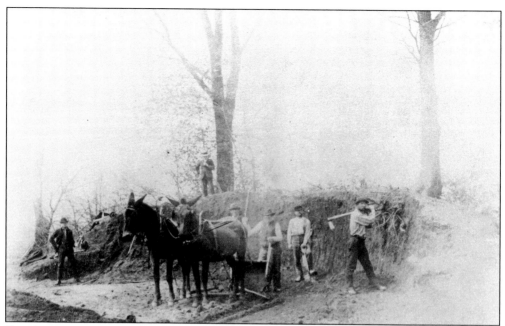

Fort Ancient is a series of earthworks built on a bluff overlooking the Little Miami River. The Fort Ancient site covers 126 acres and is enclosed by embankment walls up to 23 feet high. Although built by the Hopewell people between 100 BC and AD 400, the site is named for the Fort Ancient Culture, who lived near the site from AD 1000–1750. Fort Ancient is Ohio's first state memorial and is listed in the National Register of Historic Places. Above, a work crew excavates Fort Ancient in the 1890s. The photograph below shows workmen near a restored mound completed in 1934.

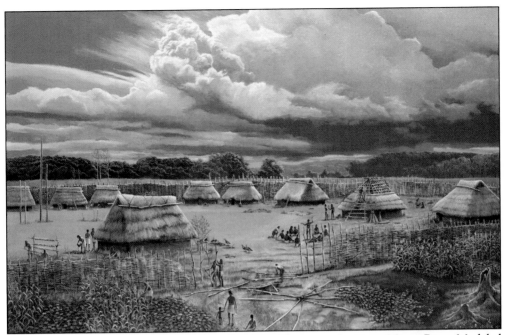

This painting depicts summer life in a Fort Ancient village near the Great Miami River. Modeled after the SunWatch prehistoric village in Dayton, this may have been a permanent settlement.

The CCC used stone retaining walls to buttress earthen walls at Fort Ancient that were built by the Hopewell people. Fort Ancient features 18,000 feet of embankment walls that were built by digging soil by hand and moving it one basketful at a time. By 1934, restoration of the earthworks was partially complete and 75 acres of trees were planted.

The image above shows visitors at the top of a mound at the Fort Ancient earthworks. The Hopewell people built Fort Ancient and other similar sites in Ohio as places to gather for ceremonial and social events. Portions of the walls surrounding Fort Ancient were used as a calendar system related to the sun and the moon. The Hopewell Culture was active not only in Ohio but also in surrounding states and had an extensive trade network reaching to the Rocky Mountains to the west and the Florida coast to the south. The photograph below shows hikers on the Fort Ancient Trail in the 1930s.

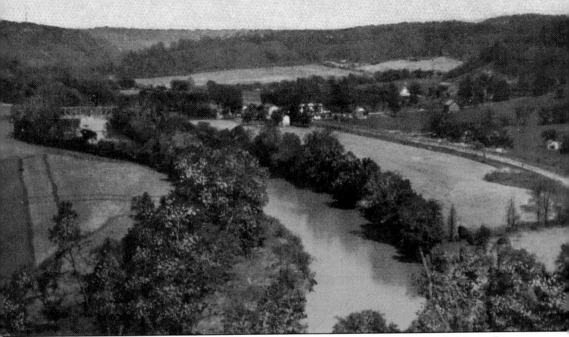

Little Miami Valley from Fort Ancient, Warren Co., Ohio.

This view looks west across the Little Miami River from Fort Ancient. The Little Miami River flows south 111 miles from its headwaters at Clifton Gorge near Yellow Springs to its confluence with the Ohio River east of Cincinnati. Between 1968 and 1971, the Little Miami was designated Ohio's first national wild and scenic river and then designated as the Little Miami State Scenic River. The river is protected by a number of nature preserves as well as by state and local parks.

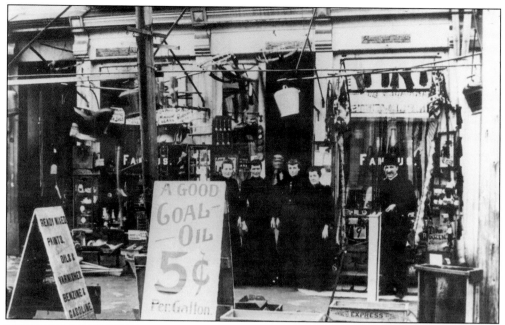

The sign outside of this general store in Xenia reads "A good Goal—Oil 5¢ per gallon." A group of men and women are gathered at the store in the 1930s. The town of Xenia was founded in 1803, the same year Ohio became a state. The name, meaning "hospitality" in Greek, was voted on in a town meeting. Xenia was incorporated by the Ohio legislature in 1817 and became a city in 1834. From 1935 to 1942, Camp Greene in Xenia was occupied by the CCC.

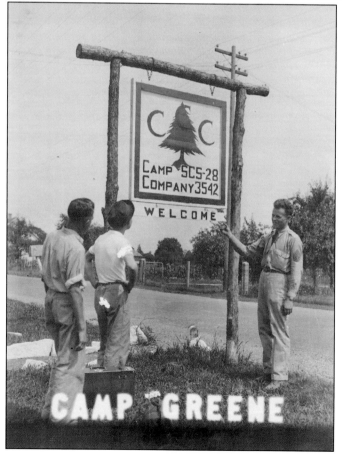

Traditionally, Tecumseh, the Shawnee chief and political leader, is thought to have been born in Old Chillicothe near present-day Xenia. Others believe that he was born along the Scioto River near present-day Chillicothe. Tecumseh grew up during the Revolutionary War and the struggle to protect Native American lands from encroachment by white American settlers who were continuously moving west. Tecumseh worked with his brother, Tenskwatawa, known as "the Prophet," to unite Native American tribes in the Northwest Territory. Tecumseh is pictured at right and below in native attire.

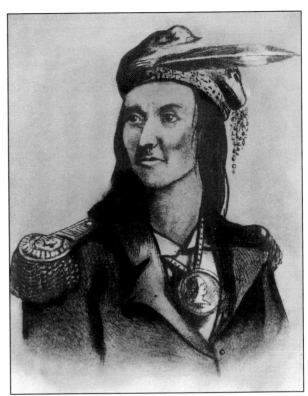

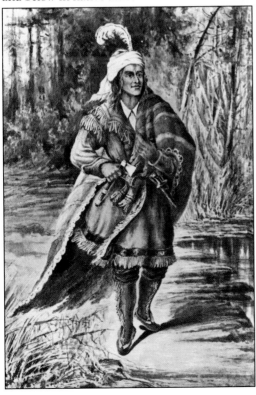

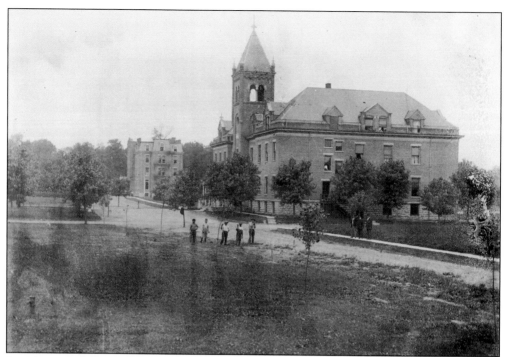

In order to provide an education for African American students, Wilberforce University (above) was established by the Methodist Episcopal Church in 1856 north of Xenia. Named for William Wilberforce, a prominent abolitionist, the university was one of the first private black colleges in the United States. In 1887, after several lean years during the Civil War, the State of Ohio offered funding to help finance the university. Below is a group portrait of Wilberforce University students.

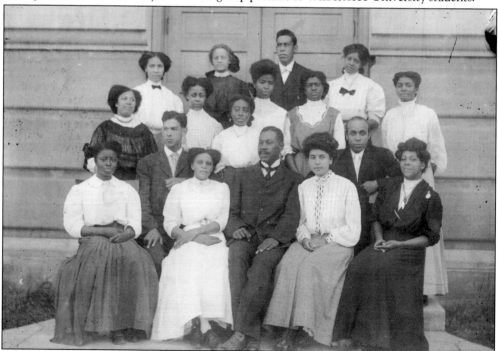

This photograph shows Steamboat Rock in the Little Miami River at Clifton Gorge, near the town of Yellow Springs. Home to Antioch College, Yellow Springs is a community of about 4,000 residents that was named for a natural spring in Glen Helen Nature Preserve just east of Yellow Springs. The spring is rich in iron, which leaves yellow deposits on surrounding rocks. The village was patterned on the utopian community of New Harmony, Indiana, and was incorporated in 1856.

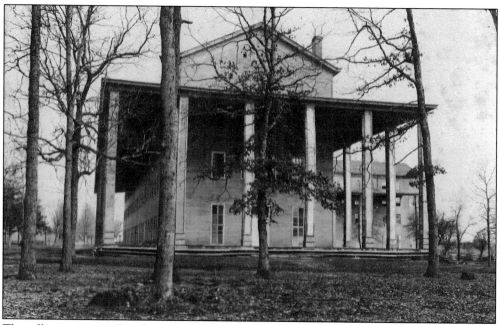

The yellow spring was first discovered around 1800 by white settlers, although Native Americans had known of the spring long before. For the rest of the 19th century, the area around the spring became a popular health resort. In 1870, a new, modern hotel known as the Neff House (above) was built near the spring. In 1925, a wealthy attorney and alumnus of Antioch College donated a part of the area around the spring to the college and named it Glen Helen for his daughter. The 1930s photograph below shows the main building in the wooded campus of Antioch College. (Both, courtesy of Antioch College.)

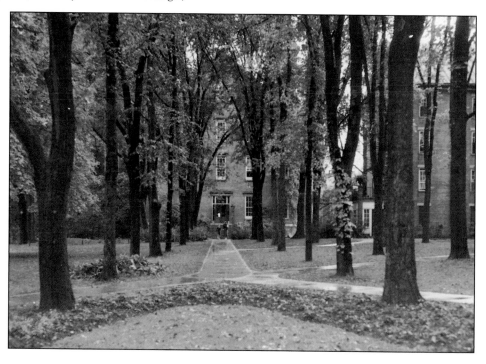

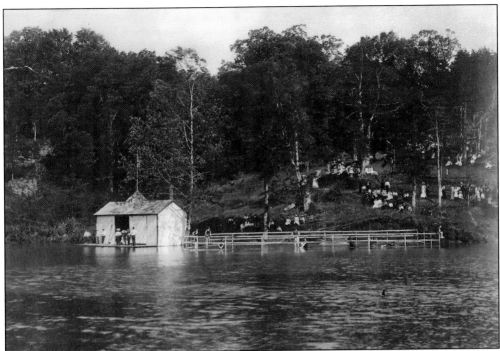

From the mid-1800s and into the 20th century, the area below the spring was dammed to form a lake to provide boating and swimming for vacationers visiting the spring. Above, bathers make use of an enclosed swimming area. The photograph below was taken from a boat looking toward shore. The area around the spring was then known as Neff Park and included many amenities for the comfort and enjoyment of visitors. (Both, courtesy of Antioch College.)

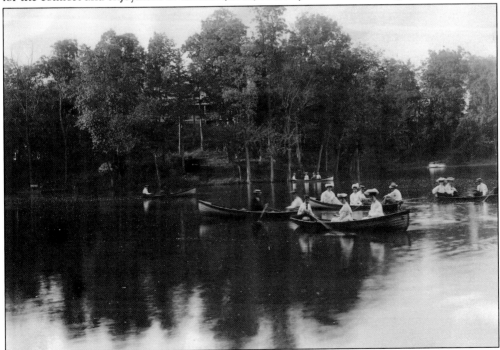

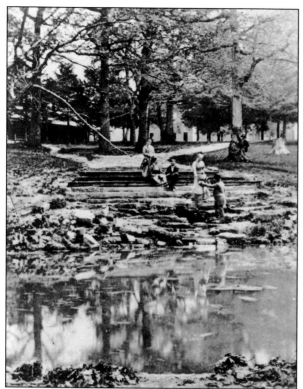

This photograph shows a typical scene at the spring with visitors sharing in the medicinal qualities of the waters. Over the years, the beneficial virtues of the waters were described as "medicinal" and later as a "cure-all" for various diseases. Yellow Springs was, in the early 1800s, an important stop on a stagecoach road that eventually connected Cincinnati with Lake Erie. In 1846, the Little Miami Railroad was completed, adding to the spring's popularity as a vacation destination. (Courtesy of Antioch College.)

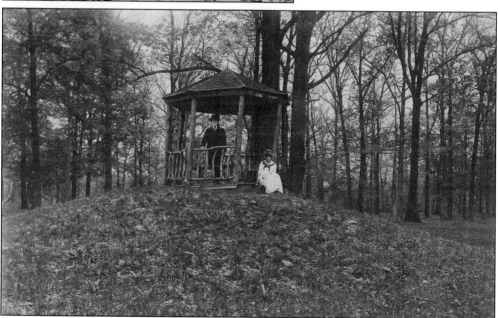

Just south and east of the Yellow Spring lies this burial mound built by the Hopewell people. The mound was excavated and found to contain human remains. Constructed between 100 BC and AD 400, the mound is listed in the National Register of Historic Places. During the 19th century, a small pavilion sat atop the mound. Orator's Mound became known as a place where dignitaries addressed crowds. (Courtesy of Antioch College.)

This limestone column is known as Pompey's Pillar. It is located on a side trail south of the Yellow Spring. About 20 feet tall from its base, the column has split from an adjacent cliff and is creeping downslope away from the cliff.

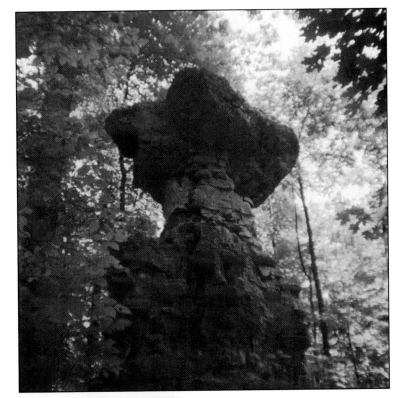

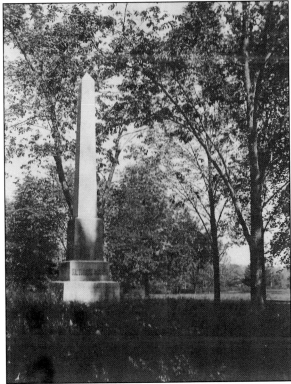

This monument commemorates the life of Horace Mann, the founder and first president of Antioch College. Founded in 1852 as a nonsectarian, coeducational college, the curriculum from the start included the study of sciences along with liberal arts, and Antioch was one of the first colleges where women students could study the same curriculum as men.

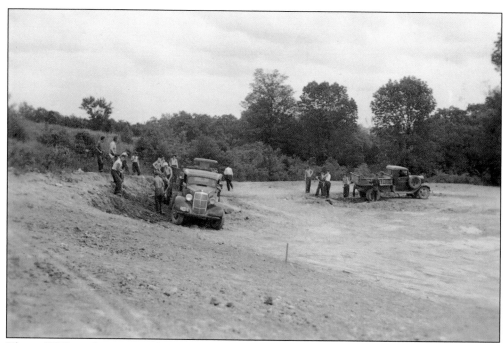

These CCC workers are grading and leveling a new parking lot in John Bryan State Park in the 1930s. John Bryan State Park is described by the Yellow Springs Chamber of Commerce as the most scenic state park in western Ohio. The park surrounds Clifton Gorge where the Little Miami River has made a deep cut through limestone beds. In 1896, John Bryan bought land along Clifton Gorge that he called Riverside Farm. In 1918, he bequeathed the land that later became John Bryan State Park to the state. The 1937 photograph below shows members of Camp Bryan attending the noon work call.

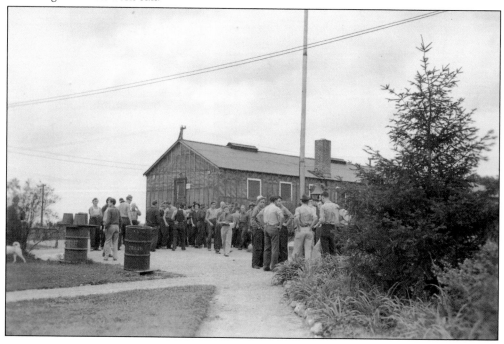

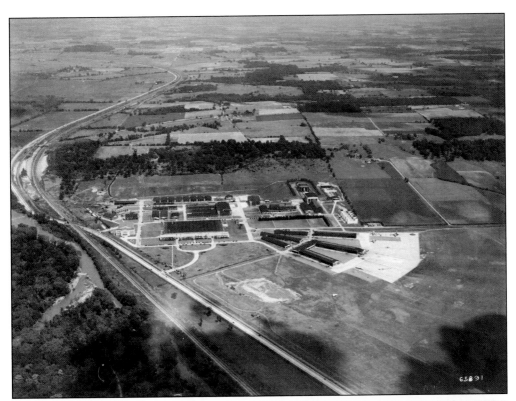

Orville and Wilbur Wright were businessmen and inventors from Dayton who are credited with inventing, building, and successfully flying the first heavier-than-air airplane. Earlier in life, the brothers had opened and run a print shop and a bicycle shop where they manufactured bicycles. Their interest in bicycles led to their interest in flying machines, and on December 17, 1903, near Kitty Hawk, North Carolina, they made the first controlled, sustained flights, traveling 852 feet in 59 seconds. Above is the Huffman Prairie Flying Field, while at right is the Wright Brothers Monument in Dayton, dedicated in 1940.

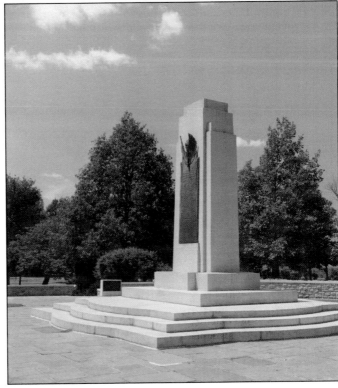

Paul Laurence Dunbar (left) was the first significant African American poet. He was born in Dayton, although his parents were slaves in Kentucky before the Civil War. Dunbar started writing poems and stories as a child and published his first poems in a Dayton newspaper at the age of 16. He died at 33 in 1906. The photograph below was taken in 1903 of Paul Dunbar and a female friend beside his home in Dayton.

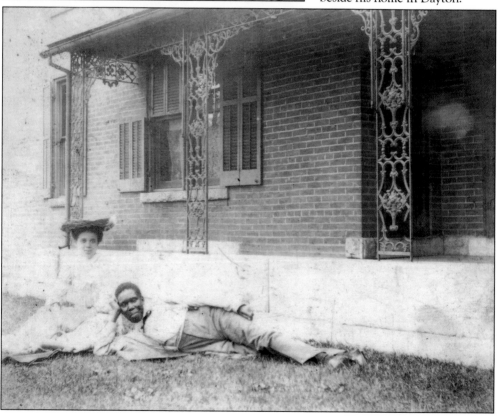

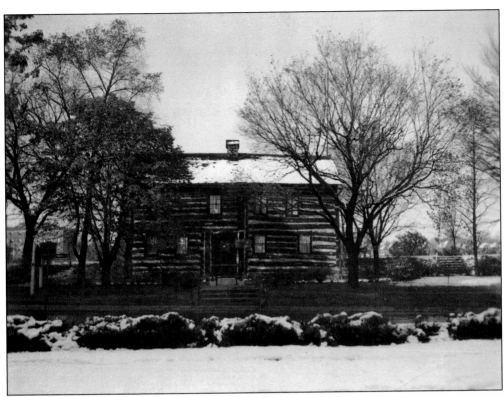

Newcom's Tavern is the oldest standing building in Dayton and now resides in Carillon Historic Park. The two-story log cabin was originally built in 1796, added on to, and moved several times. It has been a gathering place, a lodge for travelers, a tavern, and a general store. In 1894, Newcom's Tavern was donated to the City of Dayton, and in the 1960s, it became part of Carillon Park.

Carillon Historic Park covers 65 acres near downtown Dayton. Its museum, historic buildings, and exhibits concern Dayton history from 1796 to the present. The historical parts of the park were envisioned by Col. Edward Deeds, a Dayton industrialist. The park is named for the Deeds Carillon. Built in the Art Moderne style, the carillon tower is 151 feet tall and has 57 bells commemorating members of the Deeds family. In 2005, the Deeds Carillon was listed in the National Register of Historic Places.

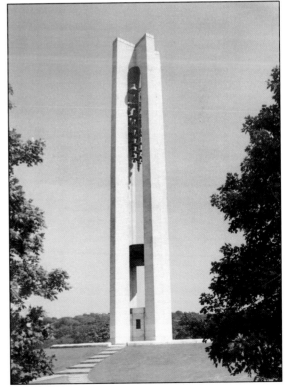

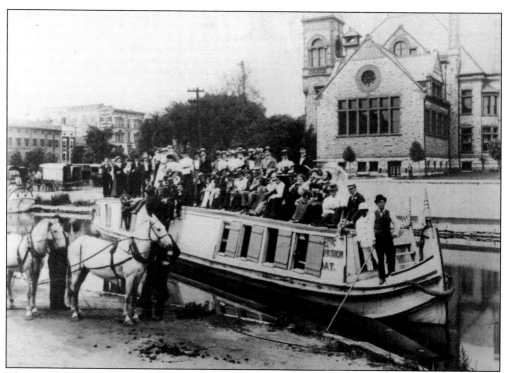

The 1888 photograph above shows a throng of people aboard a boat on the Miami & Erie Canal in Dayton. This was during the height of popularity of the canal system, 43 years after it was completed. The Miami & Erie Canal connected the Ohio River near Cincinnati with Toledo in northern Ohio. In 1822, the Ohio legislature created the Ohio Canal Commission. Once completed, the Ohio Canal System reduced the cost to ship freight to and from the East Coast from $125 per ton to $25 per ton. Below is the canal boat *Dayton* resting in the canal in 1911, near the end of the canal era.

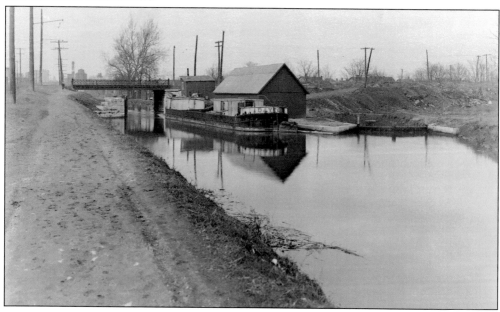

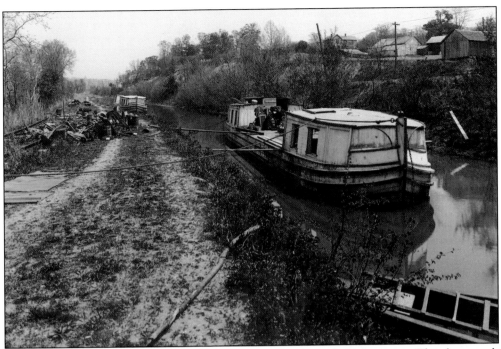

These two photographs show the Miami & Erie Canal in the early 20th century. The photograph above of two canal boats was taken near Dayton in July 1904, while the photograph below shows a gate leading into a lock near Dayton in 1911. When completed, the Miami & Erie Canal was 274 miles in length and climbed 395 feet above Lake Erie and 513 feet above the Ohio River. By the early 20th century, the canal was in decline due to competition from the railroads, and it was abandoned for commercial use in 1913.

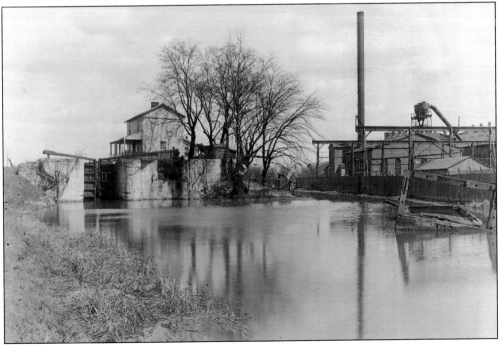

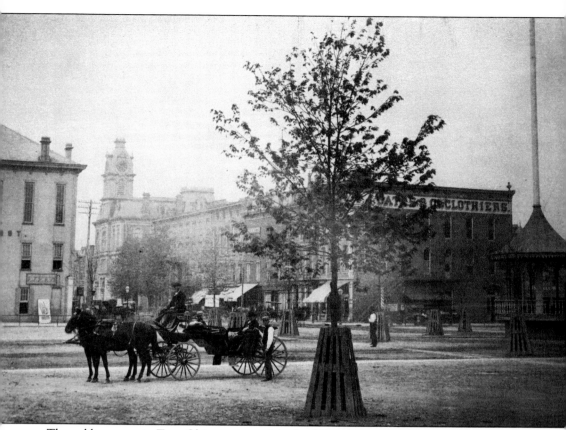

The public square in Troy, Ohio, is pictured in the 1880s. Troy, now the seat of Miami County, was platted in 1807. In the foreground are a horse and buggy, a gazebo, and several businesses, while a clock tower is in the background. Troy and many other communities all over Ohio were impacted by the great flood of 1913.

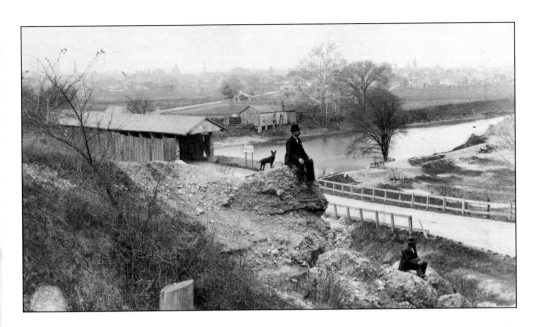

The well-dressed men above are shown in the 1880s sitting above a covered bridge crossing the Great Miami River. The city of Piqua is in the background. Piqua was settled in 1780 near the site of the Battle of Pickawillany, where British forces were attacked by Ottawa and Ojibwe warriors. Incorporated in 1807, Piqua developed along with the Miami & Erie Canal. Piqua is also the name of one of the five divisions of the Shawnee people. Below is a monument to the Battle of Pickawillany erected in 1898 on the battleground of Fort Pickawillany.

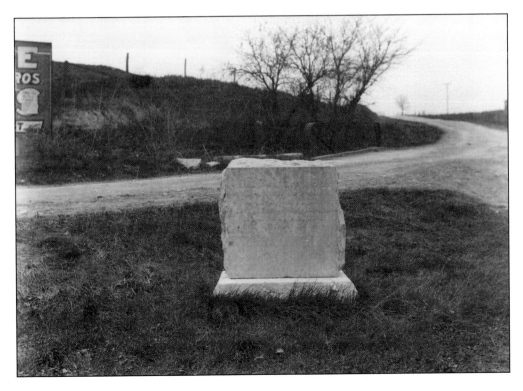

The Miami & Erie Canal is pictured above passing the John Johnston farm in Piqua. Johnston had a long career as a public servant. He served Presidents Thomas Jefferson, James Madison, and Andrew Jackson as an Indian agent and held that position until the 1840s. In 1811, an Indian agency was established in Piqua, where Johnston had good relations with the local Shawnee and Wyandot tribes. Johnston founded Kenyon College and served on the board of Miami University. At left is his farmhouse.

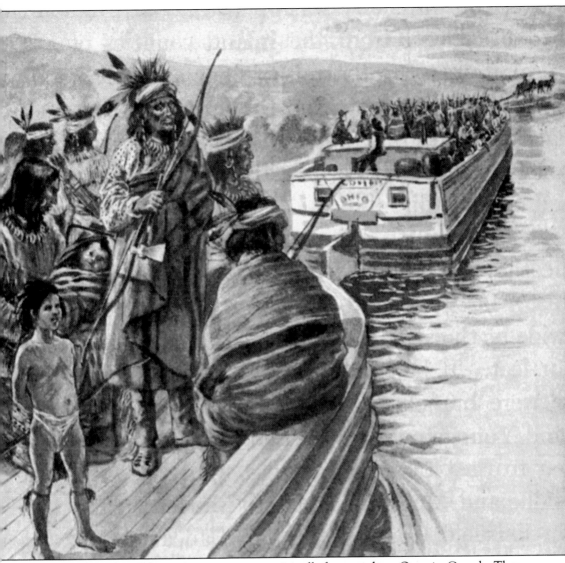

The Wyandot tribe of Native Americans came originally from southern Ontario, Canada. They were driven from their homeland and settled in northern Ohio in the 18th century. Although the Wyandots lived in northern and western Ohio as far south as Ross County, by 1842, they had given up claim to their lands in Ohio. John Johnston helped negotiate the Treaty of Upper Sandusky, which sent the Wyandots to a reservation in Kansas. Here, the Wyandots are being moved by canal boat on the Miami & Erie Canal.

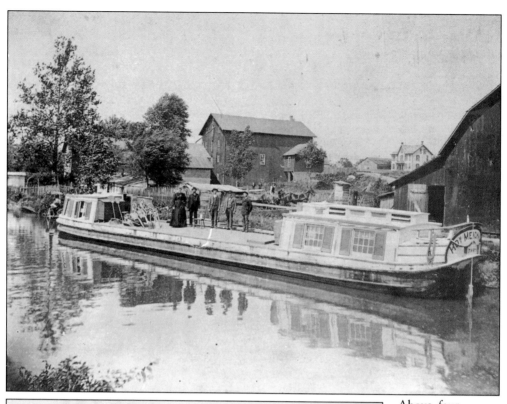

Above, four
well-dressed
men and a lady
pose aboard the
Homer Meacham
in 1896. Several
other men in the
background also
seem to be posing
for the photograph.
The gathering
took place on the
Miami & Erie
Canal near St.
Mary's in Auglaize
County. At left
is a section of the
Miami & Erie
Canal that still
remained in 1964.

The Northwood Lighthouse, shown here, is on the north shore of Grand Lake St. Mary's. The 50-foot-tall lighthouse, built in 1923, originally served as a seasonal navigational aid between April and November. Grand Lake St. Mary's was built in 1845 and was, at that time, the largest man-made lake in the world. The lake took seven years to build and was needed to feed water into the Miami & Erie Canal when water levels were low.

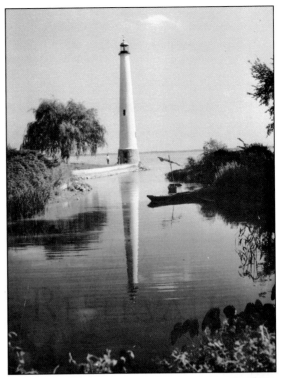

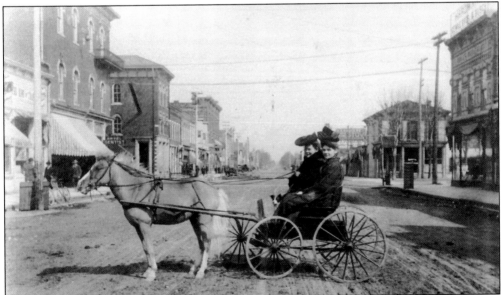

The two women in this late 19th century photograph seem to be enjoying an outing in downtown Delphos. The village of Delphos was settled by German immigrants in 1851 in anticipation of the building of the Miami & Erie Canal in the area. The location led to prosperity as businesses grew that served the canal. As with many such towns in Ohio, the transition to railroads caused a decline in the late 1800s. Delphos lies along the route of the Lincoln Highway, the first coast-to-coast highway in the United States. Named for Pres. Abraham Lincoln, the two-lane highway was built in Ohio in 1915 and connects New York with San Francisco.

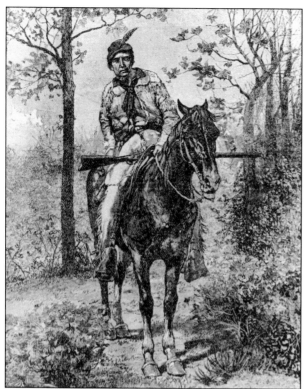

Simon Girty lived most of his 77 years on the Ohio frontier. He was born in 1741 in Chambers Mill, Pennsylvania. In the mid-1700s, he was adopted by the Seneca tribe in the Ohio Country. Girty learned much about Native American culture and language and was sought after by both the Americans and the British during the Revolutionary War. After the war, Girty aided the Native American tribes in resisting further settlement of the Ohio Country.

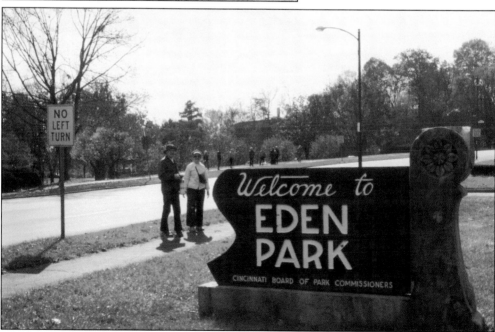

Two hikers are pictured near the southern terminus of the Buckeye Trail at Eden Park in Cincinnati. Taking off from the main loop trail at Milford, the Buckeye Trail follows the Little Miami River valley for about 12 miles to the Ohio River Monument, a 30-foot-tall granite obelisk that marks one end of the Buckeye Trail.

Five

DEFIANCE TO BRECKSVILLE RESERVATION

The boundary between the Glaciated Central Lowlands province and the Huron-Erie Lake Plain province is marked by a subtle change in landscape. The glacial landscape south of Delphos, characterized by moraines and water-deposited glacial landforms, gives way to a flat plain with clay-rich soils and poorly developed drainage. The Lake Plain province follows the Maumee River watershed to the east, where the Maumee drains into Lake Erie. East of Toledo, the province narrows and follows the Lake Erie shoreline into eastern Ohio.

The continental glaciers of the Pleistocene epoch formed a barrier to water flow to the north of present-day Ohio. Meltwaters from the glaciers became impounded south of the barrier, forming a large glacial lake known as Glacial Lake Maumee. About 14,000 years ago, at the end of the Wisconsin Glaciation, the glaciers melted and retreated to the north, allowing the meltwaters in the lake to drain. Much of northwestern Ohio was then exposed lake bottom, which grew into an extensive landscape of forests, wetlands, and marshes called the Great Black Swamp. Also included in the Huron-Erie Lake Plain province is the oak savannah ecosystem of the Oak Openings region southwest of Toledo.

Until the mid-19th century, this area was a wilderness due to difficulty of travel, clouds of mosquitoes, and malaria and other diseases. White settlers avoided the area, but the Treaty of Greenville in 1795 and settlement of the Ohio interior forced Native American tribes to live near the Great Black Swamp. Although the swamp was impassible during the wet season, by the 1840s, settlers were draining the swampy areas and cutting the forest. The Great Black Swamp was largely drained and settled by the end of the 1800s.

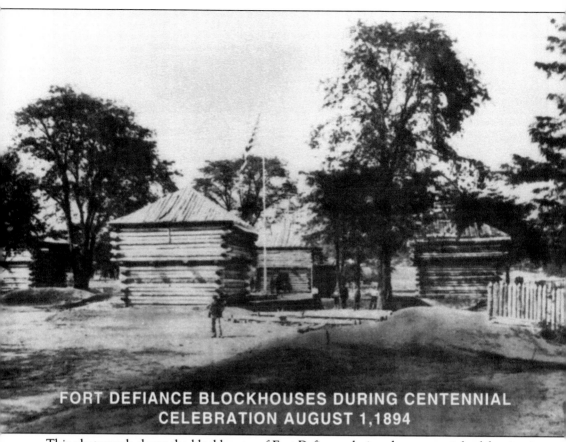

FORT DEFIANCE BLOCKHOUSES DURING CENTENNIAL CELEBRATION AUGUST 1,1894

This photograph shows the blockhouses of Fort Defiance during the centennial celebration in August 1894. The fort was built by Revolutionary War hero Gen. "Mad" Anthony Wayne in preparation for the Battle of Fallen Timbers, which took place 100 years earlier along the Maumee River near present-day Toledo. The battle pitted the Native American Western Confederacy against the United States for control of the Northwest Territory. (Courtesy of the Defiance County Library.)

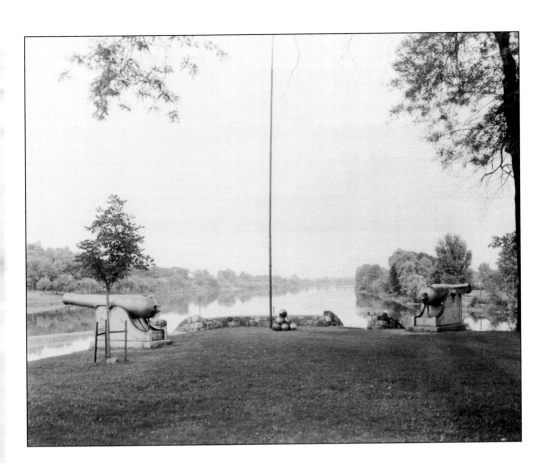

The small hill in these two photographs is the site of the memorial for Fort Defiance. Above is a view looking northeast, while the photograph below looks to the southwest. The fort was built at the point where the Auglaize River joins the Maumee River. After the Battle of Fallen Timbers, the site of the fort was used as a trading post and later by Gen. William Henry Harrison as Fort Winchester during the War of 1812. (Both, courtesy of the Defiance Public Library.)

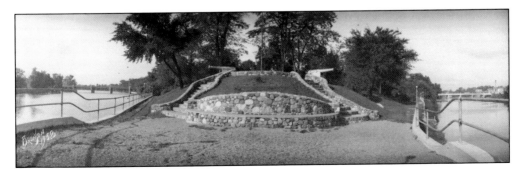

This view looking east shows the Maumee River from the grounds of Fort Defiance. The town of Defiance was established at the site of Fort Defiance in 1822 and became a city in 1881. Fort Defiance is now occupied by a public park that was listed in the National Register of Historic Places in 1980. (Courtesy of the Defiance Public Library.)

The French Indian Apple Tree is thought to have been planted by French missionaries who lived here in the 1600s. The monument to this tree lies on the north side of the Maumee River across from Fort Defiance. The base of the monument shows the diameter of the tree to be nine feet. The tree, which fell in a storm in 1887, was 45 feet tall with a branch spread of 60 feet. (Courtesy of the Defiance Public Library.)

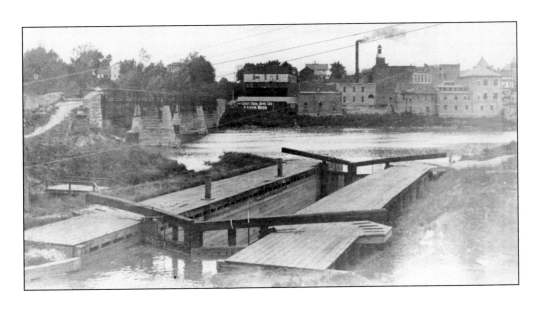

These two photographs, taken in the early 1900s, show the Miami & Erie Canal in the foreground where it meets the Maumee River from the south, with the Canal Mule Bridge in the background. Above, the lock is vacant, and Defiance is in the background. Below, a canal boat seems to be preparing to cross the river. (Both, courtesy of the Defiance Public Library.)

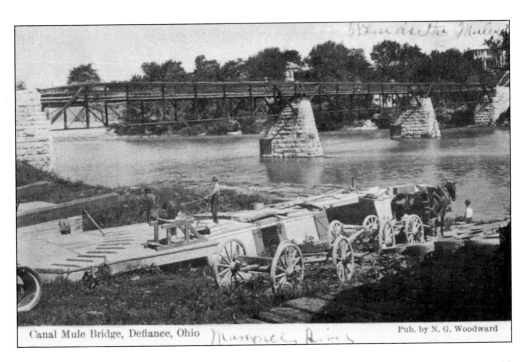

Canal Mule Bridge, Defiance, Ohio Maumee River Pub. by N. G. Woodward

Independence Dam State Park lies along the north bank of the Maumee River about four miles east of Defiance. The park was established in 1949 as an outdoor recreation area and is the site of the Independence Dam. The dam was originally built in the 19th century to provide water for the Miami & Erie Canal, which passes through the park. Independence Dam is pictured in 1916, eight years before it was replaced by the existing concrete structure.

The Miami & Erie Canal, in the foreground, ran along the north side of the Maumee River across northern Ohio, reaching Toledo where the Maumee River enters Lake Erie. This photograph was taken in 1901 near Grand Rapids, about 25 miles east of Defiance. (Courtesy of the Wood County Public Library.)

Roche de Boeuf stands as an island in the Maumee River at Waterville. The island is an outcrop of natural limestone and has a rich history as a landmark and a gathering place where several Native American tribes held council. In 1794, Gen. Anthony Wayne marched his army east along the river to Roche de Boeuf and built Fort Deposit near where the Native American forces were camped. The Battle of Fallen Timbers took place just southwest of Maumee.

ROUCHE DE BOEUF.
The Peace Grounds and Old Council Grounds of the Indians. Maumee River
Above Maumee.

This monument commemorates the Battle of Fallen Timbers and is at the site of the battle. Listed as a national historic landmark, the monument represents Gen. Anthony Wayne flanked by a Native American scout and a settler. Two stone markers in front of the statue venerate the American soldiers and the Native Americans wounded or killed in the battle.

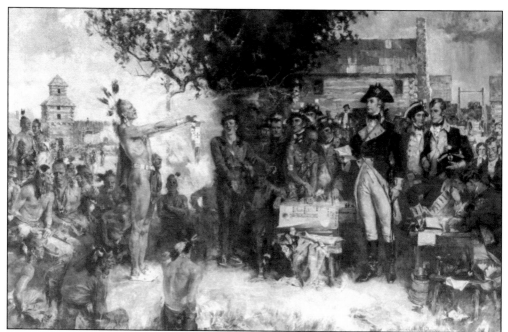

The Signing of the Treaty of Greenville is an oil painting by Howard Chandler Christy. After the Battle of Fallen Timbers, representatives of the defeated tribes met with Gen. Anthony Wayne in January 1795. Eight months of negotiations followed, culminating in the treaty that was signed in August 1795. The painting depicts the signing ceremony with Wayne on the right and Chief Little Turtle of the Miami tribe on the left. The treaty confined the Native Americans to the northwest region of Ohio.

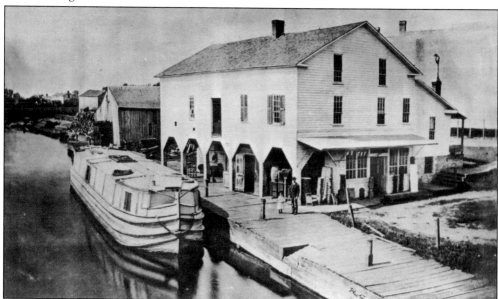

Rupp's Canal Store opened in 1854 in Waterville, just south of Toledo. The Miami & Erie Canal was completed to Waterville 12 years earlier and sparked several years of prosperity for the town. In 1851, there were 400 canal boats doing business on the canal. This photograph, taken in the 1880s, shows a canal boat moored to a post on the boardwalk in front of the store.

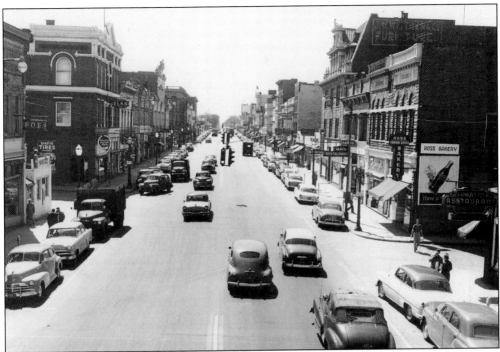

Above is a view down a busy city street in downtown Bowling Green. The village was first settled in 1832 and was named for Bowling Green, Kentucky, by a retired postal worker who had once lived there. Oil and gas reserves were discovered in Wood County in the 1880s, leading to a boom in the local economy. Bowling Green became a city in 1901 and is the home of Bowling Green State University. Below is an oilfield in the town of Cygnet, just south of Bowling Green. Ohio was a major oil producer from 1895 to 1903.

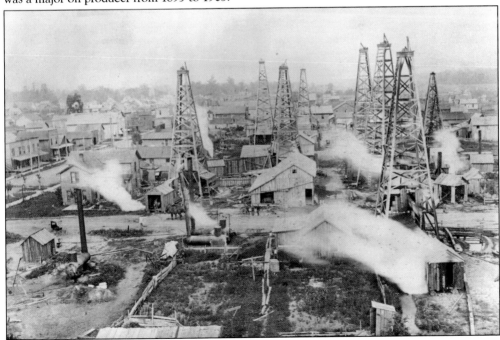

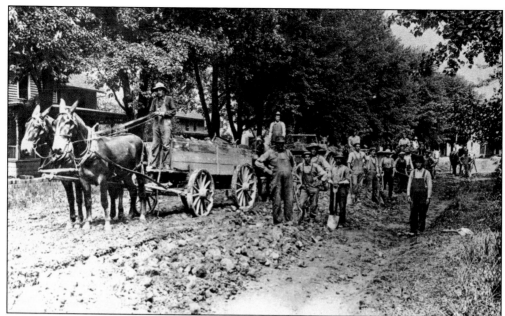

Workers use a mule team to remove dirt from Main Street in Pemberville. The dirt was used as fill adjacent to the Portage River at the edge of town. Main Street was then paved with brick, which can still be seen today. The Portage River flows northeast from its headwaters and joins Lake Erie at Port Clinton. (Courtesy of the Pemberville Public Library.)

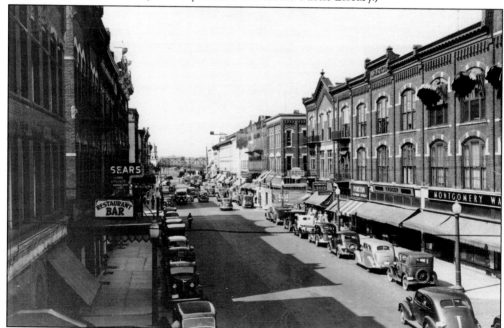

This photograph looks down the main business street in Fremont in 1939. In the mid-1800s, the town that was to become Fremont was known as Lower Sandusky. The Sandusky River flows through Fremont on its way to Sandusky Bay in Lake Erie. Lower Sandusky was the site of Fort Stephenson, built during the War of 1812. By 1849, the town had become prosperous, and the name was changed to Fremont.

114

These photographs show Birchard Park near the center of Fremont. At right, a path leads through the park, while the photograph below was taken near the edge of the park with adjacent homes in the background. The park was dedicated in 1871 on land donated to the city by Sardis Birchard, the guardian and uncle of Pres. Rutherford B. Hayes.

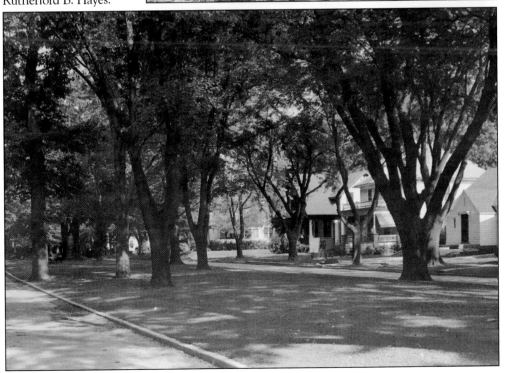

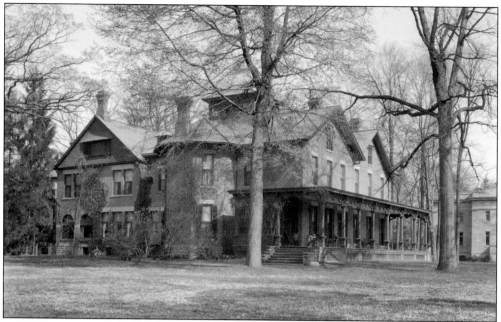

Spiegel Grove is the former home of Pres. Rutherford B. Hayes in Fremont. *Spiegel*, or "mirror" in German, was chosen because of the pools of water that formed near the home after rain. Sardis Birchard was the original owner of the home, which became the permanent residence of President Hayes in 1873. A museum and library opened near the home in 1916 and was the first presidential library. Spiegel Grove is listed in the National Register of Historic Places.

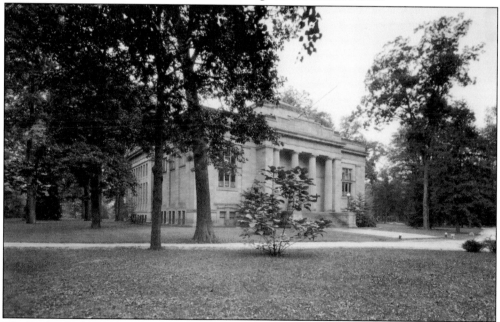

The Rutherford B. Hayes Presidential Center includes Spiegel Grove and the Hayes Memorial Museum and Library, shown here. Opened in 1916, the library is home to the personal library of Rutherford B. Hayes, his presidential library, and a historical archive of the time from the Civil War until World War I.

This monument in MacPherson's Cemetery in Clyde commemorates George B. Meek, the first man killed in the Spanish-American War; he died on May 11, 1898. In the 18th century, Native Americans of the Wyandot tribe inhabited the area. Clyde has been designated a Tree City USA by the National Arbor Day Foundation.

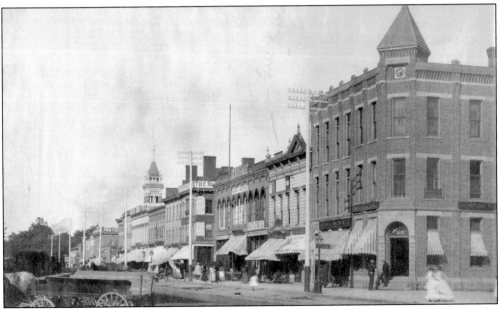

Gathy's Block in Norwalk seems to be a bustling city street in this photograph, taken in the late 1880s. Norwalk was settled in the Firelands, a region of the Connecticut Western Reserve. At the beginning of the 19th century, after several Connecticut cities were burned during the Revolutionary War, the US government ceded land to the people who had suffered losses. The settlers of Norwalk brought with them the culture and architecture of New England.

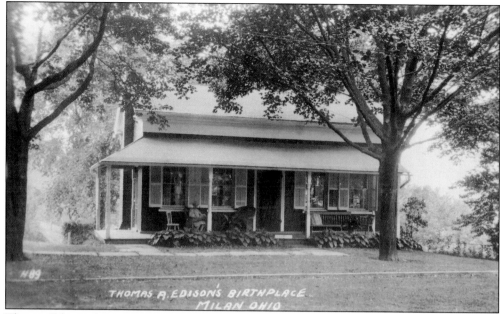

THOMAS A. EDISON'S BIRTHPLACE.
MILAN OHIO

Thomas Edison, American inventor and businessman, was born in this house in Milan, Ohio, in 1847 and lived here until he was seven years old. He was part of a large family and was taught by his mother at home. Much of his early education came from reading. Edison bought his birthplace home in 1906. On February 11, 1947, the home opened as the Edison Birthplace Museum on the 100th anniversary of Edison's birth. Below, Thomas Edison visits his birthplace in 1923.

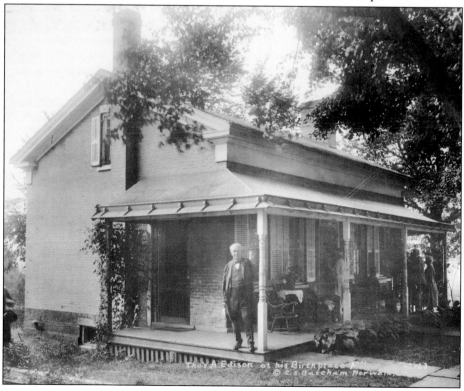

Thos. A. Edison at his Birthplace
© C.E. Batcham Norwalk

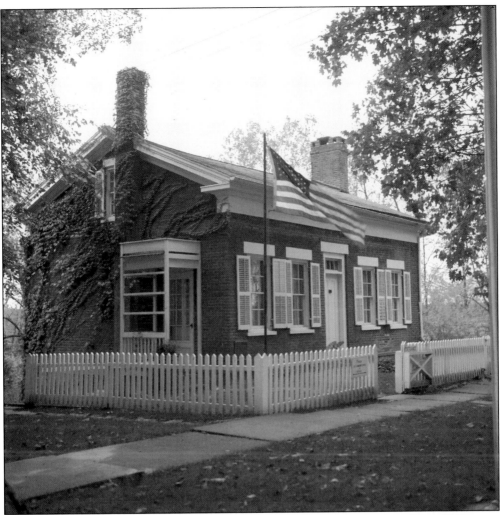

This is the Thomas Edison Birthplace Museum as it appeared in the 1960s. The village of Milan was incorporated in 1833 along with the construction of the Milan Canal. The canal connects Milan directly to Lake Erie and became necessary due to the difficulty of transporting produce by wagon. During the mid-19th century, Milan became one of the busiest ports on the Great Lakes.

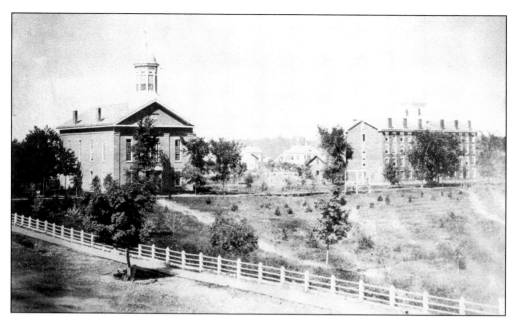

Oberlin College is near the Black River east of Norwalk. The college was founded as Oberlin Collegiate Institute by Presbyterian ministers in 1835. It is the oldest coeducational liberal arts college in the United States and includes the Oberlin Conservatory of Music, also the oldest in the United States. The college first admitted women in 1837 and was the first to admit African Americans. These two photographs show views of the campus. Above is the early campus of the 1930s, while below is the modern campus.

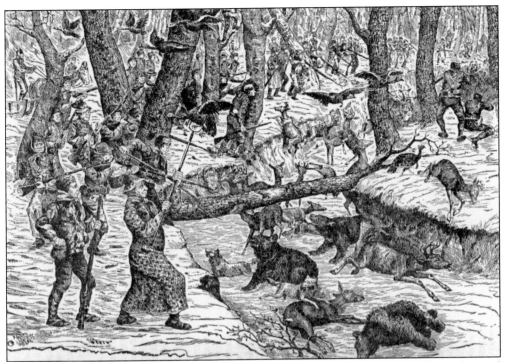

Agriculture in the early 1800s in Ohio was difficult and required much labor. Both weather and wildlife could destroy fields and harm livestock. Hunting was important to the survival of farm families. One of the most famous hunts is shown in this illustration. The "Great Hinckley Hunt" took place on December 24, 1818, in Medina County. Many animals lost their lives, but only one man was injured.

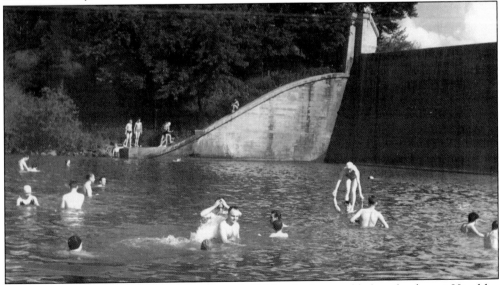

Several people in this 1940s photograph are frolicking in the pond below the dam at Hinckley Reservoir. The reservoir is part of Hinckley Reservation, which was created in the 1930s as part of the Cleveland Metropark System. Hinckley Reservation is nationally known for the return of the buzzards, who, it is thought, first arrived to feast on the carrion after the Great Hinckley Hunt.

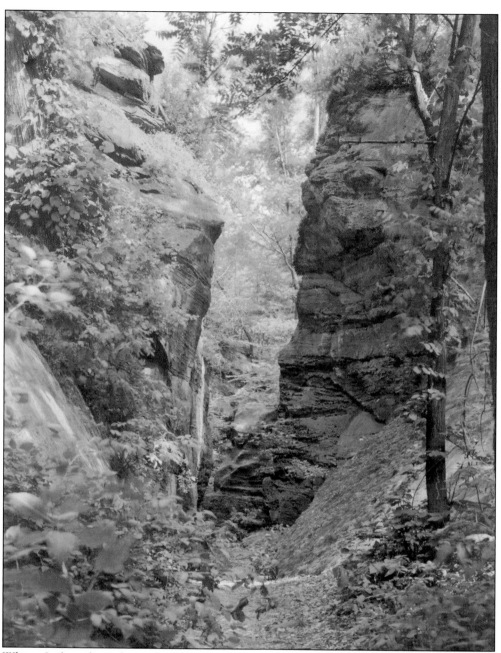

Whipps Ledges, shown here, are cliffs of sandstone and conglomerate deposited about 325 million years ago. The cliffs, which rise over 350 feet above Hinckley Reservoir in the Hinckley Reservation, were eroded and exposed during the Wisconsin Glaciation, which ended about 10,000 years ago. The cliffs have been popular with hikers and rock climbers for many years.

Six

HISTORY OF THE BUCKEYE TRAIL

The BTA officially began on June 17, 1959. Based on an idea first proposed by Merrill Gilfillan, a group of people from all over Ohio met first in May and then in August 1959 at the Columbus YMCA to create the Buckeye Trail Association. The original trail would connect Lake Erie with the Ohio River. The first section of 30 miles was cleared in Hocking County near the Hocking Hills region by Bill Miller, editor of the *Logan Daily News*, and several others. During the 1960s, the trail was completed from Lake Erie to Cincinnati. In the 1970s, the trail was extended to the north from Cincinnati to Toledo. The Buckeye Trail loop was closed at Brecksville Reservation, near Cleveland, in March 1980. Merrill Gilfillan and Bill Miller are the two most credited as creators of the Buckeye Trail. Also there from the beginning were Robert Paton and Emma "Grandma" Gatewood. The purpose of the BTA is to promote the construction and maintenance of a statewide trail system within Ohio to provide outdoor recreation, education, and opportunities for volunteers and the general public to enjoy the many and varied resources in the state.

The Buckeye Trail Association is a volunteer-run management organization and a social group. Events are planned each year by the association and by individual groups.

Director Fred E. Morr of the Ohio Department of Natural Resources (seated, right) signs the appointment of Robert R. Paton (seated, left) of Worthington, Ohio, as state trail coordinator. Standing are Melvin Rebholz (left), chief of the Ohio Department of Parks and Recreation, and Dr. Victor Whitacre, president of the Buckeye Trail Association.

In this 1967 photograph, Gov. James Rhodes signs Senate Resolution 22, designating the Buckeye Trail as an official state hiking and riding trail. From left to right are Kenneth D. Crawford; Merrill Gilfillan; Sen. Harry Armstrong; Governor Rhodes; William S. Miller, president of the Buckeye Trail Association; Sen. Ralph Regula; and Robert R. Paton.

During the 10th annual meeting of the Buckeye Trail Association in 1969, Emma R. "Grandma" Gatewood was named director emerita of the BTA. In this photograph, Dr. Victor Whitacre (left) is presenting Gatewood with a lifetime membership to the BTA. Also pictured is John P. Bay.

The Buckeye Trail Association dedication at Mogadore Reservoir was held on October 10, 1970. The dedication commemorated the completion of the then-500 mile BT. This was the original goal of the BTA—to build a trail starting at Lake Erie and ending at the Ohio River in Cincinnati. From there, the Buckeye Trail was extended north into northwestern Ohio and east to the Toledo area. The loop was closed at Deer Lick Cave in Brecksville Reservation in March 1980.

Francis Murphey of the *Akron Beacon Journal* took this photograph at the 10th annual meeting of the Buckeye Trail Association in April 1969. The occasion was a contest to select a design for the shoulder patch to be the official symbol for the BTA. Of the designs submitted, two were chosen as finalists and were combined into the design that is still used today. The officers in the photograph are, clockwise from left, Grandma Gatewood, director; John P. Bay, vice president; James H. Ucker, director; Donald L. Vogt, president; Robert E. Merkle, treasurer; and Robert R. Paton, executive director. (Courtesy of the *Akron Beacon Journal*.)

The dedication of the final leg of Ohio's Buckeye Trail was held on March 20, 1981. Gathered around the "Crossroads of the Buckeye Trail" sign are, from left to right, Ralph Ramey, BTA president; Lou Albert, National Park Service; Emily Gregor, BTA; Lou Tsipis, executive director of Cleveland Metroparks; Robert Teater, director of the Ohio Department of Natural Resources; and Ed DeLaet, BT trail supervisor.

DISCOVER THOUSANDS OF LOCAL HISTORY BOOKS FEATURING MILLIONS OF VINTAGE IMAGES

Arcadia Publishing, the leading local history publisher in the United States, is committed to making history accessible and meaningful through publishing books that celebrate and preserve the heritage of America's people and places.

Find more books like this at
www.arcadiapublishing.com

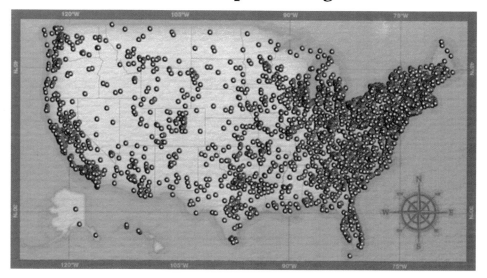

Search for your hometown history, your old stomping grounds, and even your favorite sports team.

Consistent with our mission to preserve history on a local level, this book was printed in South Carolina on American-made paper and manufactured entirely in the United States. Products carrying the accredited Forest Stewardship Council (FSC) label are printed on 100 percent FSC-certified paper.

MADE IN THE USA